CHARLESTON BEER

CHARLESTON BEER

A HIGH–GRAVITY HISTORY
OF LOWCOUNTRY BREWING

TIMMONS PETTIGREW

Photography by Chrys Rynearson

Charleston · London

THE
History
PRESS

Published by The History Press
Charleston, SC 29403
www.historypress.net

Copyright © 2011 by Timmons Pettigrew
All rights reserved

Cover design by Karleigh Hambrick.
Cover images by Chrys Rynearson.

First published 2011

Manufactured in the United States

ISBN 978.1.60949.244.1

Library of Congress CIP data applied for.

Contents

Acknowledgements

T hanks to Ken Hawkins and TheDigitel Charleston for giving me a forum to write about beer and the encouragement to make me think I could do it.

Thanks to The History Press for reading my work there and taking a chance on me.

Thanks to the dedicated staff at the South Carolina Historical Society, the South Carolina Rooms at the Charleston County and Florence County Public Libraries, the Historic Charleston Foundation and Accessible Archives for preserving a wealth of information on our city.

Thanks to the good folks at the Charleston Beer Exchange, COAST Brewing, Frothy Beard Brewing, Holy City Brewing, Low Country Libations, Palmetto Brewing, Southend Brewery and Smokehouse, Westbrook Brewing and the one and only Jamie Westendorff for being gracious with their time.

Thanks to everyone pushing the craft beer agenda in the Lowcountry, be they producers, purveyors or consumers.

Thanks to Ryan Chesley for bringing me into his circle of local beer geek friends and being generous with amazing bottles before he knew me very well at all. He really, really wanted to be in this book. Ryan, dreams do come true. That's his pint glass on the cover.

Thanks to my family for their support. Thanks especially to my wife, Summer, who endured untold earfuls of anxiety over this project and always feigned interest as she watched her husband add "history geek" to his already sizeable list of geeky interests.

Introduction

Writing a book about beer history is harder than you think. Sure, it sounds glamorous and exciting. Beer is fun by definition, so writing a book about the history of it must be a jaunty little venture, right? And who could possibly pass up all the liquid "research" that must be conducted along the way?

Don't get me wrong, this has been a hugely fulfilling, enjoyable experience, and woe is definitely not me. Much was learned during the course of my (paper-based) research. The surprise in all this was not what I learned from the pages and manuscripts I read, but what I learned from the lack of pages and manuscripts. There is simply not a huge, rich history of local beer knowledge waiting out there at your fingertips, at least not of the magnitude I expected. The major players that started in the 1800s and are still dominant today assuredly have great record-keeping, but I was after a more localized, people-centric story. Beer is touted as the common denominator of American history, so why the dearth of information?

Research on the general debauchery that went on during our nation's younger years yields almost solely stories about spirits. Research about taverns will lead you to learn about liquor. Research about Prohibition is full of "lips that touch liquor..." quotes and tales of bathtub gin. So where is beer's place in all of this?

The conclusion I've drawn is that beer's place was so ingrained, so much a part of the everyday life of American culture, that it was wholly unremarkable. Before we had sanitized water and indoor plumbing,

citizens of all ages drank beer of some sort in order to get hydrated without getting sick from water-borne diseases. Brewing was part of the regular duties of a rural housewife. That's not to say that this culture was born in America; it just made its way over the pond during colonization and naturally hung around.

The integration of beer into everyday life can be traced far before and beyond Merry Olde England, however. It's thought that beer, like other alcoholic beverages, was an accidental discovery by a brave soul imbibing some old fruit or soaked barley that had been fermented in the open air. A more tangible history began in Sumeria, where the first written language teaches us that beer was a ubiquitous beverage consumed by folks in all walks of life. Its uses ran the gamut from medicine to ritual.

Civilizations rose and fell over the coming centuries, and beer was spread throughout North Africa and Western Europe along with the culture of the conquerors. Wine eventually took a stronger hold in grape-growing regions, while beer found a more permanent home in areas rich in grain production. It was there, specifically in Northern Europe, where brewing started as a household task and moved later to also be the province of the clergy. Many excellent varieties are still produced in monasteries today, where "liquid bread" became a form of sustenance and a gift for weary travelers.

Our children learn that the pilgrims landed on Plymouth Rock, but they are less often taught that this was due to a detour resulting from the seafarers running out of beer. Later, after founding the first colony in Virginia, it took less than a year for the governor to send word back to England that they were in desperate need of brewers. He astutely noted that "to plant a colony by water-drinkers is an error that will result in ill health."

So the records of war abound, literature about the nature of our government and what it should be are plentiful and even tales of whiskey-induced bacchanalia are easy to find, but beer remains a scantly referenced subject. Upon reflection, you can't blame our ancestors for not chronicling the exploits of beer culture like they would a war or even shipping records. Beer was about as interesting and novel to them as soda pop is to us today. It was a given.

Despite our centuries-long love affair, beer has been unwoven from the fabric of American life. The concept of temperance, rising from the urbanization of the 1800s, changed the game completely. Even after Prohibition was repealed, its stigma remained. Beer today is a treat for adults only, not intended to be an everyday, all-day affair as a matter of course. We have strayed so far from the European model of drinking, which itself has

changed as well, that drinking culture is unrecognizable to what it was in olden times.

Because of this new paradigm, beer has become interesting again. Our ways have changed enough that our old ones have become fascinating. But beer has also become interesting due to the craft beer boom. Over the last thirty-odd years, small American brewers have become adventurous, and American beer drinkers have followed suit. Following the national legalization of home brewing in the late 1970s, the practice of making interesting, flavorful, complex beer at home turned into an entrepreneurial exercise for many. Through the inspiration of pioneers on the West Coast like New Albion, Sierra Nevada and Anchor Steam, we now have well over one thousand breweries in the United States.

In fact, in the year 2010, there were 1,753 breweries in operation in the United States, more than ever in the post-Prohibition world. The craft brewers in this bunch contributed to an 11 percent increase in craft beer sales by volume in 2010. This growth outpaced that of the previous two years. All of this growth flew in the face of the poor economy putting a hurt on the collective wallet of American consumers and flew directly in the eyeball of macro brewers, as total national beer sales declined by roughly 1 percent over the same period. If that's not a boom, I don't know what is.

South Carolina, and Charleston in particular, is a perfect microcosm of our national beer history. Beer was once ingrained in the lives of Charlestonians. Breweries sprung up here prior to the Revolutionary War and continued until Prohibition, when they could no longer support themselves on complementary products. After years of nothingness, we, too, are now part of the craft beer boom. Our local beer scene includes four breweries, dedicated beer shops, multiple craft beer bars, a home-brewing club, an amazing annual beer festival and a growing, beer-loving populace ready to have their taste buds wowed. Some of our beer purveyors have even been nationally recognized, as we continue to work toward becoming a Southeast beer destination.

I believe it's entirely appropriate to frame Charleston's beer history as a continuum, putting eighteenth-century innovators like Edmund Egan in the same context as twenty-first-century brewers like David Merritt. What becomes apparent when making these connections is that all beer was once, technically, craft beer. Hundreds of years ago, the best beer was brewed locally by default. Drinking locally and knowing your brewer was the only option if one wanted something palatable, as opposed to poorly preserved beer shipped warm for days or weeks over land or sea. In the midst of the

craft beer boom, and likewise the ever-growing local food movement, we are reviving parts of our ancestors' lifestyle. Arguably, these are parts we'd do well not to forget.

While our culture has changed, the function of beer in our culture has not. When done right, it's a deliciously social endeavor, the glue that brings folks with myriad opinions on other topics together under its auspices alone. Here's to that continuum, well, continuing.

Chapter 1

The Thirst Begins

Charleston has a very interesting origin story surrounding its founding as Charles Towne in 1670, the first city in South Carolina. As interesting a story as it is, you won't find it here. If reading about the Lord Anthony Ashley-Cooper and his fancy associates is your bag, there is ample material out there for you. This book is about beer, and although I'm sure the Lords Proprietor enjoyed a brew on occasion, that's not the topic at hand. The most pertinent fact about the Holy City's founding is that twelve tons of beer made its way to our shores with the first settlers. Yes, twelve tons. Now that the tone is set, let's get right to it.

THE BEER-GINNING

The first notable newspaper in this then-colony was the *South Carolina Gazette*, a Charles Town–based weekly periodical that ran from January 8, 1732, through December 1775. During its time, it kept the populace up to date with everything from advertisements to notices of runaway slaves to anti-British thought and organization. It is in the advertisements that the earliest known traces of beer culture in the Lowcountry can be found.

It took less than two months of publication for beer ads to start appearing in the fledgling publication. In the issue spanning February 26 through March 4, 1732, the Beer Cellar made its presence known. Located on "The Bay,"

> **A**T the Beer Cellar, over against Mr. *El-*
> *liot's* Bridge on the Bay, is to be sold stout pale Beer at
> 7 s. 6 d. per Gallon, strong brown Beer at 6 s 3 d. per Gall.
> table Beer at half a Crown per Gallon, three Bottles of
> strong Beer at 5 s. and three of Table at half a Crown.
> Where all Persons may be supplied with Beer, either for
> Sea or Land, by Wholesail or Retail, at reasonable Rates.

This advertisement for the Beer Cellar appeared in the February 26–March 4, 1732 issue of the *South Carolina Gazette*. It serves as the earliest known evidence of brewing or direct sales of beer in Charleston. *Courtesy of Accessible Archives, www.accessible.com.*

now known as East Bay Street, this store catered to ships, sailors, taverns and citizens alike. Here they could procure a variety of offerings, including "stout pale beer" and "strong brown beer." Prices were quoted both by the gallon and the bottle at what were promised to be "reasonable rates." Its location was listed as being "over against Mr. Elliot's Bridge," which can be inferred as being near modern-day Elliot Street. Through sheer coincidence, this is roughly a block from the Charleston Beer Exchange, a current retail establishment that will be covered in later chapters.

A few months later, in the August issue, the Beer Cellar advertised once again. The name Joseph Morgan was now attached to the operation. At this point he was running the show, as at the time he "continueth to sell beer as usual, and carrieth on the brewing"—the earliest known evidence of commercial brewing in the city. Morgan noted that this was going on in the home of his deceased father. However, there's no indication whether his father was running the original Beer Cellar during the February advertisement or whether this was a reference to his location if perhaps his father's home was well known.

Whatever the lineage, Joseph Morgan did not keep the establishment running very long. In February 1734, all the remaining equipment in his father's brewing operation was put up for sale by Samuel Holmes, in addition to a "parcel of malt." With such scant information, it's difficult to deduce exactly how Holmes came into the picture, only that he ran the ad in conjunction with a call to collect any debts owed to the estate. He was not selling the store at this time, only the brewing equipment.

The story now goes silent until early 1736, when Holmes pops up again in the *South Carolina Gazette* advertisements. He had designs to leave Charles

CAROLINA BEER

AT *Four*, *Eight*, and *Twelve* Pounds by the Barrel, also in half Barrels and Ten-Gallon Kegs for small Families, and any Quantity of YEAST (always allowed to be far preferable to Leaven in the making of BREAD) from a Pint upwards, at 5 *s. per Quart*, made and sold by NATH. SCOTT,
 Brewer, from LONDON,
At his BREW-HOUSE in one of Mr. Middleton's Tenements, in QUEEN-STREET.

The said SCOTT being now fully determined to proceed in the *Brewing* Business; having hitherto been obliged to procure his Materials from *England*; and conceiving, that every Man should GIVE (as well as have) the Preference and all Encouragement possible, in whatever Country he resides; assures the Public, that all the BEER by him made, and vended, as such, shall be of pure Malt and Hops, and entirely free from any Adulterations whatever (which are too common, and very pernicious); and that he will so far prefer and encourage the People of this Province, as to contract, with so many Gentlemen Planters as will, for *Four Thousand* Bushels of BARLEY, yearly, to be delivered between the first Days of *September* and *March*, at *Fifteen* Shillings per Bushel, if good; and to give *Twenty* Pounds, for every *Hundred* Weight of good well-cured HOPS; which will enable him, at the same Time, not only to sell his Beer cheaper, but also to make it better and stronger (much of the Barley that is imported being spoiled in the malting, and both Malt and Hops in the Carriage): But, as he cannot be supplied here against the ensuing Season, he has already sent to *England* for Barley; yet makes no Doubt, that the *Carolina Planters*, from the Encouragement he now offers, will prevent future Importations of that Kind by
 NATHANIEL SCOTT.

Nathaniel Scott took out a particularly large ad in the February 22, 1752 edition of the *South Carolina Gazette*. In it, he touts the products of his brewery and entices local farmers to grow both barley and hops, which he then guarantees to purchase and use to brew. *Courtesy of Accessible Archives, www.accessible.com.*

Town in mid-1737 and was selling off a number of things to make his voyage possible. He put up his own land for sale, as well as the location of the original Beer Cellar. Holmes either had no luck selling Morgan's brewing gear two years prior or had procured his own gear, as he once again was selling "utencils fit for brewing of beer [*sic*]." It appears the Beer Cellar was still operating too, though perhaps under a different name, as the ad ends with listings for both "fine pale beer" and "sider" [*sic*] by the gallon at his store on The Bay, with discounts by the barrel.

Daniel Bourget was a contemporary of Morgan and Holmes, brewing and selling beer on Church Street from at least late 1732, when his first ad appeared, through early 1736. He ran three ads over these four years, always ending them with roughly the same tagline: "There is also good entertainment for horses." He was a producer of "strong, middling, and small Beer," beer styles of varying strengths that will be covered in short order.

Bourget ran no adverts from 1736 through 1739, but by then he had changed occupations. Still working with grains and yeast, Bourget was now a baker. His appearances in the *Gazette* that year had him embroiled in what appears to have been a price war, as he called out other bakers for pricing their bread too high and was then himself called out for selling loaves that did not weigh exactly what was advertised. By 1744, it seems Bourget had left the cutthroat bread racket and invested in real estate, leasing some apartments on Middle Street. He was in the ladies' apparel business in mid-1751 and died at the age of seventy-five in 1770.

Early brewer number three was Nathaniel Scott, a transplant from London. His brewery, situated in a tenement on Queen Street owned by a member of the well-to-do, plantation-owning Middleton family, was the home of "Carolina Beer." From there he sold yeast for making bread, as well as beer packaged in casks of varying size, from barrels to half-barrels to ten-gallon kegs. In today's world, a ten-gallon keg is also known as a Cornelius or "Corny" keg. Scott advertised these as being especially suited for "small families."

His equipment and ingredients came largely from his home country, and he advertised as such in a 1752 edition of the *Gazette*, but Scott had bigger plans. There would always be a modicum of waste in shipping perishable malted barley and hops over the Atlantic, resulting in relatively fewer ingredients for the price paid. This all translated into slightly weaker beer than Scott wanted. He saw a weaker beer as preferable to a stronger one made with "adulterations," which he noted were "all too common, and very pernicious." Commitment to quality and purity was

a theme shared by early Charlestonian brewers and modern-day ones, as you'll find out later.

It was Nathaniel Scott's goal to kick-start the local production of barley and hops with area farmers. His initial call was for an annual yield of four thousand bushels of barley. For this, he would pay fifteen shillings per bushel. Likewise, he offered twenty British pounds "for every Hundred Weight of good well-cured hops." There is always something to be gained by fresher ingredients, but Scott presented this plan instead as a path to stronger beer for his customer base and a break from dependence on English goods. This would be a win-win for a thirsty populace with growing anti-English fervor.

Outside of his newspaper advertisements, no further information on his brewery or its fate could be found.

The Saga of Edmund Egan

Correspondence and newspaper advertising make up what's left of the story of Edmund Egan, much of which was collected by Walter Richard Walsh in a 1955 article appearing in the South Carolina Historical Magazine. *The article, and further research into its sources, provides the basis for much of this section.*

From the city's founding in the late 1600s through the mid-1700s, the beer consumed here was largely imported. Pennsylvania and Connecticut were common sources. This was a growing and thirsty port city, so the benefits of a more locally produced product were apparent. Beer could be fresher and cheaper if made closer to home, as the cost and time of transportation would be cut drastically. While the opportunity was there, the city had only the few aforementioned entrepreneurs seizing upon it. The city's next brewer would take things to the next level.

Edmund Egan arrived in the Lowcountry sometime in the early 1760s. There are no authoritative records of his whereabouts before then, but his later advertisements indicate he, too, came from England, where he studied the art and science of brewing as an apprentice to a London brewmaster. He intended to set up a brewery here, but upon surveying his situation in Charles Town, he faced a few challenges. Outfitting a brew house did not come cheap, and with no known businesses like it in the area at the time, any equipment would have to be shipped to him. Finding financing was especially difficult due to his status as an unknown newcomer.

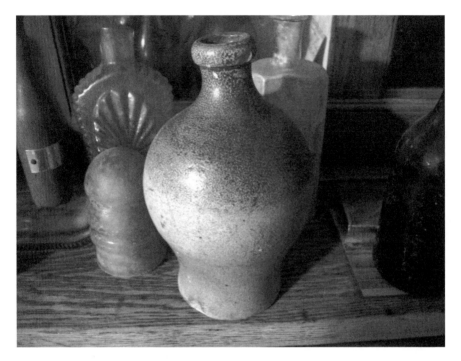

Fired clay or ceramic bottles like the one depicted here were of the type used to import beer in the 1700s. Its opacity would protect beer from any light damage on the voyage, and its thickness made for a sturdy container over sea or land. *Photo by Timmons Pettigrew, bottle from the private collection of Jamie Westendorff.*

Egan's first attempt at starting up was through a local merchant named Henry Laurens, later president of the Second Continental Congress. He asked Laurens to contact some sources in Philadelphia for the highest-quality malted barley and hops in 1762. Laurens obliged, but to no avail. With no equipment and no ingredients, Egan turned to teaching fencing to pay the bills, and in 1764, he went into business with Nathanael Green and William Coats. Together, the gentlemen were "woodsellers, carters, and factors handling indigo, rice, and lumber for the planters on commission."

In 1765, the English transplant found a strange bedfellow in English legislation. The passage of the British Stamp Act led to a huge rejection of British imports in Charles Town. Some went as far as to stage complete boycotts of their imports, but even more moderate citizens had a renewed thirst for American-made products. As some beer was still being imported from as far away as Liverpool, the conditions were right for founding a new brewery in Charles Town.

John Calvert partnered with Edmund Egan to start the brewery. Calvert was soundly anti-British, fueled by his following of Christopher Gadsden, head of the Sons of Liberty and later leader of the South Carolina Patriots during the Revolution. He wanted a brewery in Charles Town on principle alone, though clearly he had no moral objections to it. Advertisements appeared in the *South Carolina Gazette and Journal* in 1766, noting their selection included "Double brewed Spruce Beer, table and small beer," all of which they would ship to a customer ordering more than five gallons. They also sold their well water to locals in three-month increments and found early competition to be much stronger in this department, as they were the only brewery operating in the area.

COLONIAL BEER STYLES

The beer styles Egan and his predecessors offered are largely unrecognizable in the twenty-first-century market, for a few reasons. Spruce beer was a popular style at the time, one of a number of improvised styles from early American brewers. With no ready supplies of barley or hops, colonial brewers had to look to the land for palatable ingredients. Spruce acted as a makeshift substitute for hops, providing some added flavor and bitterness. Beer was also commonly brewed using molasses in place of malted barley. A certain painting of George Washington pictures him with a beer recipe in hand, noting both molasses and bran as ingredients.

The styles also refer to the conservation efforts of early brewers. In an effort to get the most of their ingredients, and without the exacting temperature-control technology of modern brewers, colonial brewers would brew multiple times using the same supply of starch (be it malted barley or a substitute). Each subsequent batch would have less and less alcohol, as more sugar would be extracted during the first boil and less was left for the next. Double beer would be produced from the first boil, with table beer being next (served quite literally at the dinner table) and small beer last. Small beer had very little alcohol but still enough to ward off microorganisms. It would be consumed throughout the day, even by children.

THE BUSINESS OF BREWING

Henry Laurens was now acting as the pair's agent for ingredients, which were successfully coming in from the Northeast. While the issue of receiving the goods was resolved, the issue of their quality was problematic. In a letter to his contact, Laurens remarked that the low-quality malt and hops were leaving their business "half in ruins." He ended up seeking better-quality goods elsewhere, and the brewery continued onward. In another odd turn of events, the boycott of English goods that proved instrumental in the brewery's opening rose its head again but this time acted to its detriment.

British Parliament passed the Townshend Acts in 1767, reigniting the anti-import fervor that had risen up during the Stamp Act two years prior. This time, the boycotts were more severe, almost completely halting trade in the port of Charles Town for about eighteen months starting in the middle of 1769. No imports meant no malt and no hops, leaving Egan and Calvert's brewery in dire straits. A lack of beer may not be as bad as the other results of the acts, which included the Boston Massacre, but it was certainly a time of grave concern for the pair.

By early 1770, the brewery was on the market, and Egan seized the opportunity to become manager with the help of a few unnamed investors. By the end of the year, the boycotts had subsided, and he immediately acted to prevent his no-ingredient nightmare from happening again. The shortsighted move would have been to order as much malt as possible. Astutely, Egan instead invested in barley seeds. With the help of a plan very similar to Nathaniel Scott's, soon local farmers were cultivating barley specifically for his operation. His offer was difficult to refuse. The seeds were offered to farmers for free, and they were in turn guaranteed

DOUBLE BEER, fine Ale, Table and Small Beer, Yeast for Baking, and Grains good for Cows and Horses, at the Brew-House, by EDMUND EGAN.

One of the first advertisements bearing Edmund Egan's name, from the October 4, 1770 issue of the *South Carolina Gazette*, lists four varieties of beer for sale at his brew house, along with baker's yeast and spent grain to feed livestock. *Courtesy of Accessible Archives, www.accessible.com.*

> # B E E R,
> **E**QUAL to any that shall be imported, and House-Keepers may be regularly supplied the Year through with DOUBLE and TABLE BEER, from the *Brew-House*, by
> ## EDMUND EGAN.
> *N. B.* GRAINS for Horses and Cows, and YEAST for Bakers, constantly.

As Egan's ads continued, so did the increase in his confidence. In the November 26, 1772 issue of the *South Carolina Gazette*, he lists his offerings as normal but prefaces them with a note that his beer is not only consistently available but just as good as the imported alternative. *Courtesy of Accessible Archives, www.accessible.com.*

that the yield would be purchased in full. What's more, they were guaranteed that their local brewer would not run out of beer again! This does not speak to the higher-quality product Egan could brew given fresh, local grains from the start.

The following years would see the Charles Town brewery start to boom. In 1771, a large addition was added to the building, and more high-quality malt was being brought in from the Northeast, while local farmers tended to their first crops of barley. By the next year, Egan was in the *South Carolina Gazette and Journal* again, not just due to advertisements, but due to the editor writing about the quality of his product. Thomas Powell remarked that his brews were "superior to most that is usually imported from the Northern Colonies."

This newfound attention must have filled Egan with pride. His advertisements became increasingly confident from 1770 to 1774. At first they had only listed the beers he offered, but soon the beer was described as being "equal to any that shall be imported." Later, it would be "equal to any imported from any other country." Finally, he started publicizing his new slogan. "Let the beer Justify itself" sounds like the motto of a playfully boastful craft brewery in the twenty-first century, but it belonged to a small Charles Town brewery in 1772.

Word was starting to spread about Egan's beer. Local tavern keepers soon preferred his beer to any other, as it continued to outsell imports by greater and greater margins. At one point, his old agent and friend Henry Laurens had to put an unwanted supply of beer imported from Philadelphia up for auction. He took a loss, thanks to the superior beer of his client quickly becoming the best game in town. Egan was now

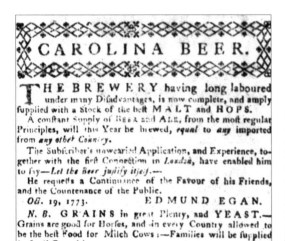

CAROLINA BEER.

THE BREWERY having long laboured under many Disadvantages, is now complete, and amply supplied with a Stock of the best MALT and HOPS.

A constant Supply of Beer and Ale, from the most regular Principles, will this Year be brewed, *equal to any* imported from *any other Country*.

The Subscriber's unwearied Application, and Experience, together with the first Connection in London, have enabled him to say—*Let the Beer justify itself.*—

He requests a Continuance of the Favour of his Friends, and the Countenance of the Public.

Oct. 19, 1773. EDMUND EGAN.

N. B. GRAINS in great Plenty, and YEAST.—Grains are good for Horses, and in every Country allowed to be the best Food for Milch Cows;—Families will be supplied in small Quantities.

By the November 22, 1773 edition of the *South Carolina Gazette*, Edmund Egan had clearly hit his stride. His brewery was fully outfitted, and by his own word, his beer was as good as any import from "any other country." Here we see for the first time his boastful motto: "Let the beer justify itself." *Courtesy of Accessible Archives, www.accessible.com.*

clearing an estimated £20,000 British annually, which is somewhere in the neighborhood of $3 million U.S. in today's terms. He was supplementing his income from beer sales by selling spent grain as feed for farm animals, another move popular with modern, eco-friendly craft breweries.

While Egan was brewing beer, a desire for revolution was brewing in the populace. Though British by birth, Egan threw his hat in the ring with his now-fellow Americans. He exposed Loyalists and loaned the significant sum of £14,000 to the state for the war effort. There were further supply issues during the coming years, though little of it is documented.

Continued expansion through 1778 gave him increased capacity, to the point where his beers could be sold colony-wide. The Magazine Street brewery had two large kettles, a malt grinder capable of handling "one-hundred bushels a day" and, of course, myriad bottling and barreling supplies. By now there were eight slaves on the proverbial payroll, doing everything from building barrels and casks to doing the brewing. In the midst of all this growth, Egan was ready to leave the business in August. His plan was to retire and sell the brewery and all its assets (including the slaves).

The motives are unclear, but his next move was attempting to open a distillery on Comings (now Coming) Street with a set of new partners. They were able to build some infrastructure in the plant, but Egan was soon distracted by real estate dealings and exited the distillery partnership before it opened. The next year, he left Charles Town and did not return until 1786. This was likely due to the turmoil plaguing the city and its businesses due

to the Revolution. Upon his return, he re-entered the distillery partnership but passed away before it opened for business. His brewery survived and was being run by Thomas Gregson in 1790. In the same year, the distillery was also open and being run by Henry Geiger.

Taverns Abound

It took some time for breweries to start sprouting up in Charles Towne, but taverns were another story entirely. One could not expect a new port city full of a rotating cast of transient seafarers to go long without a place to drink, talk and relax (in any number of ways).

Some of the earliest taverns did their best to cater to sailors by setting up shop on "the finger piers built out from the Cooper River bluff," near Albemarle Point. Apparently even seventeenth-century barkeeps knew how to take advantage of a captive audience.

It wasn't until the 1680s and 1690s that taverns started cropping up inland or moving there. Pier space was needed for buildings to house cargo and conduct business, more pressing priorities than convenient watering holes for sailors. While the entertainment moved inland, demand for it from the port was ever increasing. Well over one hundred ships were coming through Charles Town each day by 1720, with crews numbering from about ten to over fifty. Mark Jones estimates in his book *Wicked Charleston* that at least "eighteen hundred sailors from a dozen foreign ports [took] their liberties" here at any given time in those days.

The Bay played host to many such establishments. One taproom located on its intersection with Broad Street was operated by Mary Bailey Cross, known for her escapades with a Middle Eastern sultan some years prior.

Chalmers Street (then Mulatto Street), one block north of Broad and running from Meeting to State Streets, likewise became a center of nightlife. Its seedy reputation was thanks to it housing as many brothels as it did taverns, if not more, although there was surely some overlap between the two. Its most famous joint was number 17, the Pink House, which opened about 1712 and remains standing today after multiple natural disasters. The party couldn't last forever, and the city government eventually caved in to the clamor of concerned citizens and cleaned up the area around the year 1800.

Not every tavern was a hotbed of debauchery—at least not every night. Many of the estimated over one hundred taverns, taprooms, public houses, inns and punch houses in colonial Charles Town also

functioned as community centers and meeting places, just as they had in Western Europe. Local organizations like the Hibernian Society, the St. Andrews Society, the Amicable Club, the Harmonical Society and the South Carolina Society were born from and thrived via tavern meetings. If there's one thing old Charlestonians loved, social clubs were clearly it. While these all sound like benign fraternities, more ambitious groups like the Sons of Liberty were also organizing in taverns, sowing some early seeds for the American Revolution.

Dillon's Tavern on Broad Street, City Tavern, Pointsett's and the Carolina Coffee House were just a few of these taverns-cum-town halls. Shepheard's Tavern, located on "the northeast corner of Broad and Church streets," also aptly referred to as the Corner Tavern, is noted as being the site of Charles Town's first Masonic meeting in 1736. Later, in May 1801, it became the birthplace of the Scottish Rite of Freemasons order, now a national organization. Charles Shepheard's spot was also an early playhouse, with part of the establishment (the "courtroom") rented out to the local government as it tried to add some cultural spice to the area. This civility must have worked to balance out the cockfights that were also held there.

McCrady's, located just off The Bay in Unity Alley, famously entertained President George Washington in 1791 during his tour of the South. Edward McCrady's tavern opened originally in the early 1770s, but it was in 1778 that he opened his "long room," where Washington would eventually visit. This was an extension of the tavern, a more specialized space for entertainment and large parties. That building would remain a tavern throughout the 1800s, eventually becoming home to a printer in the 1900s and nearly being demolished before concentrated restoration efforts turned it into the beautiful restaurant it is today. In the excavation preceding the restoration, a collection of handblown, likely beer-bearing glass bottles from the eighteenth century were uncovered.

Rules for the Unruly

With all the sailors, taverns and sailors drinking in taverns, Charles Towne had its hands full trying to keep the peace. That said, it seems the city understood their commercial importance. When a "sober Sabbath" bill was introduced in the 1690s, taverns were not explicitly mentioned as being

liable, only drinkers. This law crept forward in the coming years, first with a fine of five shillings for drunkards caught red-handed on Sunday in 1691 and next with a twenty-four-hour jail sentence in 1692.

It was not until 1712, with a perceived increase in Sunday drinking, that legislators applied the fine of five shillings to both barkeep and drinker. This was coupled with a requirement that "constables and church wardens" make the rounds twice on Sunday looking for violators, "empowered to break down any door" upon suspicion alone.

Despite the strength of the law and intention of its writers, prosecutions (or records of them) are extremely rare throughout the state during this time. More common were charges against tavern owners of "operating a disorderly house," prostitution, contributing to the delinquency of minors or trafficking in stolen property.

In addition to the Sabbath law, there were licensing requirements for taverns. Part of a license was payment of a bond by the prospective licensee to cover the behavior of his or her clientele. There was much concern about unruly behavior, especially from the burgeoning slave population and poor laboring class immigrating into the budding agricultural economy. This bubbled into the first tavern regulation being passed in 1694, but it did little more than reiterate that drinking could cause drunkenness and that taverns needed a license. This trend of toothless legislation bemoaning the growth of taverns continued through the early 1700s. As long as their license fees and bonds were filling the governor's coffers, there was little political will to limit them, especially while the governor's office was also acting as licensor.

This conflict of interest was uncovered and rectified by the legislature in 1711 by way of a law that held both the barkeep and the licensing agent liable if the licensee proved unfit or in violation of the law. The law also divorced the fee collection from the governor's office. While this sounds good, there were some issues. The law stated that the joint approval of three men, who appeared in the law's language by name, was needed to license a tavern.

The three men died.

With no official licensors, all bets were off. Unlicensed and poorly run taverns were cropping up everywhere. It wasn't until 1741 that the law was revisited, putting licensing in the hands of two magistrate positions and severely limiting the pool of licensees. Anyone who could ably do any of a list of artisanal professions was barred from getting a license.

Whatever hoops one had to jump through to open a tavern, they remained a ubiquitous Charles Town institution. Mark Jones describes

the city's tavern-scape as the American Revolution approached: "In 1763, sixty-six tavern licenses were issued. Five years later the number had doubled—approximately one tavern for every five adult males. Half the licenses were issued to women. It was illegal for artisans to operate a drinking establishment, so most dodged the law by having their wives obtain the licenses."

So what do all these taverns have to do with beer? Although there has been little to no mention of beer in them thus far, it was clearly a popular beverage served in each of them. At one time, a single Charles Town tavern's monthly supply included eighteen thousand bottles of ale. Swallow's Tavern was noted for serving beer made from molasses and persimmon. We know breweries were operating here, and we know importation was happening that the breweries competed against. Yet despite the volume sold, or the interesting variety, there is little historical record of specifics. Almost all of the legislation written refers to wine or liquor, especially "strong liquor," when deriding the evils of tavern culture. One must conclude again that beer was an unremarkable, everyday drink that was ingrained in the lives of tavern-going Charlestonians and escaped the blame for the evils of alcohol and the thrill of debauchery.

Chapter 2
The First Boom

Throughout the 1800s, beer was being professionally brewed in Charleston. But fast-forward to 2011 and not much is left to prove it. German immigration started in earnest in the city in the mid- to late 1700s, and those immigrants famously started grocery stores, saloons and eventually breweries. Records are scarce or nonexistent, recipes are long gone and the property the breweries may have existed on has been repurposed. Glass bottles are one thing that survived, and if nothing else, they prove that beer was made here. Collectors have unearthed old beer bottles embossed with names such as Claussen, Jessen and Kornahrens. However, with no additional back story, there's little one can say other than the fact that they "were."

Two breweries, or rather one that changed its name midstream, have some available history one can use to piece together what's left of their story. Those breweries are Palmetto Brewing Company and, later, Germania Brewing Company, both names for a mammoth operation that churned out beer downtown on and off for at least sixty years.

PALMETTO, TAKE 1

Perhaps the most well-known historical Charleston brewery, thanks to its modern counterpart to be covered later, is Palmetto Brewing Company. Unfortunately, there is not a clear narrative history left for it. What can

be pieced together from invoices, stock certificates, newspaper articles and advertisements paints a picture of a large operation woven into the fabric of the city. Many of these articles are on display at the modern-day Palmetto Brewing Company.

The earliest piece of surviving evidence that Palmetto existed is an invoice dated 1857. This establishes it as an antebellum brewery, but it's altogether likely that the operation was slowed, if not stopped outright, during the Civil War and brief Union occupation. The founders were named John and Henry Döscher, either German transplants or descendants of immigrants, based on their last name. The records of their history become richer as the timeline moves out of Reconstruction and into the 1880s.

About this time, more dated material is available. The names appearing on invoices and in advertisements are now Cramer and Kerstin. It's known that these two men were Virginians who worked as distributors for Palmetto in some capacity, bringing the beer into their home state. They also had some stock in the company though, as Kerstin's certificate is still intact. One can infer that they bought out at least a controlling share of it since their names are all over the brewery's ephemera.

BRICK AND MORTAR (AND BEER)

A diagram of the brewery also appears on some surviving receipts and certificates, along with a clear description of its location. It occupied a small city block, as well as some property across two streets. The main operation was located within and around five streets, whose names remain unchanged: Anson, Hayne, Pinckney, Church and Guignard. Based on the diagram, the brick complex housed a brew house, a steam engine room, a stock house (or warehouse), an office and a cistern outside, which collected rainwater for use in at least some of the beer. Its own ice factory/refrigeration complex was established across Pinckney Street, with its horse stables sitting adjacent to that. Across Church one would find its bottling operation, part of the brewery's name in many ads, where it is called "Palmetto Brewing Company and Steam Bottling Works." Early beer pasteurization was achieved by bathing finished, capped bottles in steam until they reached 170 degrees Fahrenheit, but steam was also a likely power source.

This raises some questions, one being: why in the world would you bottle all the way across the street from where the beer is made? The answer lies

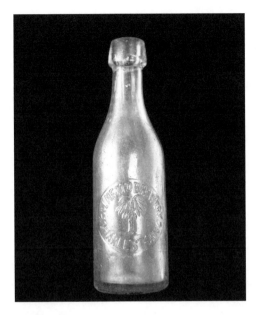

Left: This original Palmetto Brewery bottle is adorned with the palmetto tree logo. Despite its size, bottles of this type held much less than conventional bottles do. Their glass walls were kept very thick to prevent breakage. *Photo by Chrys Rynearson, bottle from the private collection of Jamie Westendorff.*

Below: This receipt from the original Palmetto Brewing Company, dated June 24, 1896, the last year of its existence, depicts an iconic palmetto tree and notes the location of the brewery. Cash payment was required on delivery, and the brewery claimed no responsibility for empties. *From the private collection of Jamie Westendorff.*

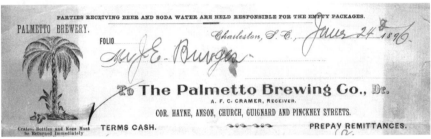

with the taxman, as it so often does. In the late 1800s, national beer taxation was based on casks or kegs; bottles had no tax levied on them. This created a loophole brewers could exploit by bottling everything before it left their property, therefore escaping taxation. The government countered this by declaring that beer had to be put in a cask or keg, and that cask or keg had to be carried over a road usable by the general public before it could be bottled. This meant every drop of beer produced would be taxed, as it would be counted while in a keg, but it made for sprawling, multi-block brewing operations and a fairly inefficient process. In some cases, the bottle works would be run by a different company, but they would still tend to be located as close as possible to their biggest brewery client. In 1890, the national beer lobby, led then by Pabst, successfully had the law changed to allow a gauged pipe to run beer from brewery to bottling operation, but they still had to be housed in separate buildings.

Palmetto's logo was a clear choice: the palmetto tree. It adorned some of the company's receipts, as well as its bottles. The brewery ran into a snag at one point as the South Carolina Dispensary (hold your breath for Chapter 3) was also in the business of bottling alcohol in palmetto-embossed bottles. The Dispensary decided the logo was too close to its own, which had in fact come later, so Palmetto was forced to tweak it. Some of its bottles employed a flip-top or lever-top enclosure, like some modern bottles do today. Most were also marked "not to be sold," indicating that the containers should be returned for the brewers to use them again.

DISASTER STRIKES, BEER FOLLOWS

One of the better-preserved parts of the Palmetto story is related to the Earthquake of 1886, a disastrous event for Charleston as a whole. On August 31 of that year, the most powerful quake to hit the eastern seaboard in recorded history struck the city. The Richter scale didn't exist until nine years later, but this thing was devastating. The main quake lasted only forty seconds, followed by another a few minutes later. The results were collapsed buildings, injured occupants, fire and panic. More buildings fell during each of the four shocks to follow. The death toll was near thirty, with thirty additional deaths occurring after the earthquake from "injuries, shock, and exposure." Damage estimates were about $6 million in 1886 dollars. Stats aside, the sheer power of the earthquake is maybe best understood by the range of its effect, described here by Jo Anne Plyler in her retrospective from a 1964 edition of the *News and*

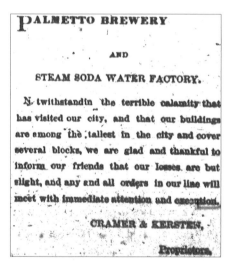

Despite major devastation in the rest of the city, Palmetto Brewery and Steam Soda Water Factory (as it labels itself here) survived relatively unscathed. In this September 7, 1886 issue of the *News and Courier*, one week after the earthquake, the brewery announces that it is open for business and filling orders. *Courtesy of the South Carolina Room at the Doctors Bruce and Lee Foundation Library, part of the Florence County Library System.*

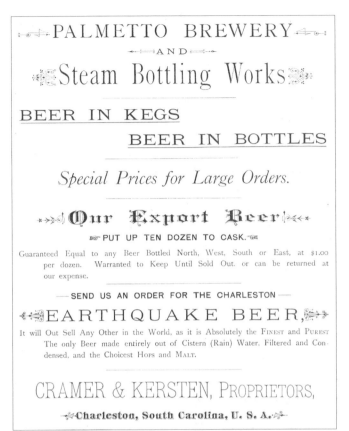

This full-page advertisement for Palmetto Brewery was collected and preserved with other documents in the city concerning the earthquake. The brewers were proud enough of this rainwater-brewed beer to make the impossible assertion that it would be the bestselling beer on the planet. *Historic Charleston Foundation.*

Courier: "Tremors were actually felt over an 800 miles radius and the shock was perceptible from the Gulf of Mexico to Canada and from Ohio and Missouri to Bermuda. Houses in southeastern Ohio oscillated quite visibly, windows were broken in Milwaukee and bells were rung in New York."

The city banded together in the face of this destruction to rebuild and move on. Palmetto Brewing Company was a part of this effort, its building having survived the tremors. The brewery advertised its survival in the *News and Courier* one week after the earthquake, touting minimal damage and promising it would work to fill outstanding orders as quickly as possible.

Three months later, the city had recovered remarkably and held a gala and parade to celebrate its resilience. Palmetto brewed a special "Earthquake Beer" to mark the occasion and served it during the festivities. The brewery was quite proud of it, stating in an ad that it would "outsell any other in the world." A bold statement, unless they meant it would outsell any other earthquake beer.

DOWNHILL FROM HERE

Palmetto ads in the 1890s featured some of its other brands. There was a beer named "Progress," a "Pilsener Export" [*sic*] and an especially popular bock, a type of German lager, called Koppelman's. This bock beer was said to be responsible for a 50 percent increase in sales in only its first week and was notably free of glucose, flavorings and "adulterations," made with the "finest German hops." An extended ad released around that time covers Palmetto in more general terms, touting the experience and quality of its brewers and its state-of-the-art machinery, both of which contributed to brewing "thousands of gallons of the delightful beverage" daily. Palmetto claimed its beer was as good as any other, including those made in American brewing stalwarts like Cincinnati and Milwaukee. The brewery's distribution

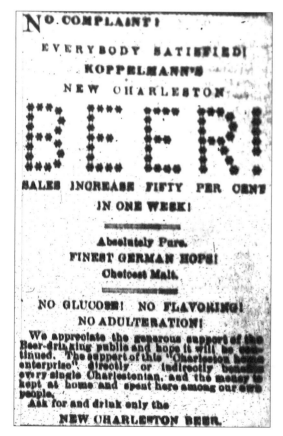

The Palmetto Brewing Company was responsible for brewing a number of brands over the years. This advertisement from the March 9, 1890 issue of the *News and Courier* proclaims that one brand in particular, Koppelmann's, showed a huge sales increase in its first week. The lack of adjuncts is particularly noted, as they are a cheap way to increase alcohol content. *Courtesy of the South Carolina Room at the Doctors Bruce and Lee Foundation Library, part of the Florence County Library System.*

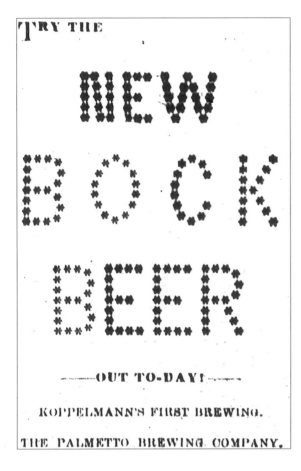

This advertisement from the April 1, 1890 issue of the *News and Courier* announces the release of a new beer from Koppelmann's Brewing, brewed at the Palmetto Brewing Company. Bock is a German lager style. *Courtesy of the South Carolina Room at the Doctors Bruce and Lee Foundation Library, part of the Florence County Library System.*

was growing to include other parts of the South, with sales following suit wherever the beer made its mark.

An excavation of a privy house, a fancy term for a bathroom building, at Middleton Plantation unearthed a Palmetto bottle dating from somewhere between 1892 and 1895, so we know it made it that far from downtown. Palmetto was still producing bottles with the embossed tree at that time, and that one in particular used a levered "lightning stopper" developed by Henry Putnam. This is evidence that Palmetto continued operating by that name at least up until 1895, but things would soon change.

GERMANIA IS BORN

Spoiler alert: the best and only source available for the history of Germania Brewing is its bankruptcy records.

At some point between 1895 and September 1896, Palmetto Brewing Company became Germania Brewing Company, and ownership transferred back to the Döschers. This time it was J.H. Döscher who took the helm, likely a relative of the previous owners. J.H. was the initial president, but ownership of the brewery was spread among his family. He retained 550 shares, while three relatives each retained 150 shares.

The circumstances are unclear as to why it was sold and why the name was changed. By now, America had embraced German-inspired lager as its favorite style, both for its crisp taste and its bright and clear appearance as glass became a more popular drinking vessel. From a marketing standpoint, the name change would have made sense. The logo conflict with the state dispensary around this time could also have played a part.

While Germania was making and selling beer, there is not much record of its success, only of its downfall. South Carolina enacted statewide alcohol prohibition in 1916, three years prior to the United States, and records of Germania's debt leading up to bankruptcy begin in 1915. The state's prohibition certainly would have destroyed the company, but it's hard to

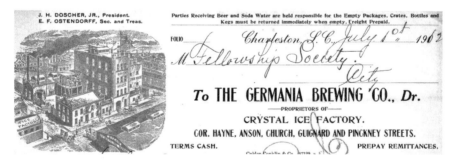

Above: When Palmetto Brewing Company became the Germania Brewing Company in 1896, the new owner salvaged what he could from the old. A diagram of the brewing and bottling complex is depicted on this receipt from July 1902, matching previous depictions of Palmetto. *From the private collection of Jamie Westendorff.*

Opposite inset: Germania Brewing Company, Palmetto's successor, used at least one different type of bottle than the original Palmetto Brewery. The palmetto tree logo is of course absent; instead, it displays a large capital "G" surrounded by lettering. The mouth of the bottle would suggest the possibility of capping. *Photo by Chrys Rynearson, bottle from the private collection of Jamie Westendorff.*

ascertain whether it was already failing prior to that. What can be said with certainty is that in 1915, the debts of the company and J.H. Döscher in particular were mounting.

Whether out of anticipation of the catastrophic law soon to pass, in an effort to diversify or just to better cool its lager, Germania was getting into the ice-making business in 1915. York Manufacturing, a refrigeration machinery company from Pennsylvania, was contracted to install some new machinery on its property that year. Germania's payments were delinquent from April to August of that year. York soon learned that the brewery was also behind in paying local ice-making plants, including Mutual-Carroll. It was not until September, after repeated wire communications

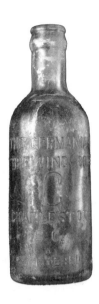

from York, that Döscher replied. He cited deficient quality in the ice from York's machinery, which was promised to generate clear and clean three-hundred-pound blocks.

Bickering turned into vitriol over this relatively minor point. In reality, ice machines of the times did not create perfect blocks. Instead, they would have a thawed, cup-shaped crater at the top. To produce a perfect block would have been totally cost prohibitive. York understood this, so its machines would produce an overweight block to make up for the difference. This was not good enough for Döscher, though one can only guess if his argument was really about ice quality or just an attempt to further stall payment. In the end, he settled with York for $3,838.92 and started the routine again with Arctic Ice and Coal Company.

Though much of the York correspondence was preserved, Germania had similar relationships all over Charleston by 1916. About $3,000 was owed to Nordberg Manufacturing, which Germania did not pay due to claims of "bad vibrations" produced by Nordberg's machinery. A lawsuit was levied against Germania by Campbell Fuel Company as well. A large chunk of change was also owed to the Security Savings Bank, which held the mortgage on the property.

In the midst of a failing business whose lifeblood was now deemed illegal by its state's government, J.H. Döscher died suddenly on May 4, 1916. The family scrambled to deal with the debts of the brewery, which had added up to $24,400 by that point. His son Gustav was forced to take control and

subsequently forced to declare the brewery bankrupt in July of that year. Under the auspices of the IRS, the remaining beer in the brewery's vats was destroyed to absolve the company of liability. At that point, the balance sheet was abysmal—$67,313.26 in assets and $100,414.44 in liabilities. The property was sold off in September for less than what was owed.

The fall of Germania was likely a story shared by many American breweries facing Prohibition. The ill-fated law worked to kill a once-thriving industry and destroy the livelihoods of many hardworking Americans. It would take decades for it to recover.

HOME BREWING, TAKE 1

By the mid-1800s, professional breweries were operating in Charleston, and its citizenry was enjoying their wares. It's likely that during this time citizens were also enjoying their own wares, the products of home brewing. When hearing this term, many no doubt think of the modern version: a picture of jolly, often bearded fellows boiling sweet-smelling liquids on stovetops or propane burners, pouring a mix of results into a giant glass jug and waiting to taste what happens. While that's a different picture than what happened during the Civil War era, and that picture will be covered later, they are all part of the same do-it-yourself continuum.

Most of the evidence left about the practice from this era is in the form of recipes printed in books or contemporary pamphlets. A number of beer recipes from all over the country were collected into a chapter of John Hull Brown's 1966 book, *Early American Beverages*. The variety of beer that American home brewers were making at the time, from this collection alone, is more than one might expect. There is, of course, the differentiation in strength, with separate recipes for strong beer, table beer and beer designed for family consumption (a likely analog to the aforementioned "small beer").

Beers made in the home were flavored with everything from ginger to spruce, lemon, maple and hops. The recipe for "Dorchester Beer" calls for sage and an addition of "sassafras root and checkerberry" when one could not procure hops. "Gas beer" contained allspice, cloves and cinnamon. "Philadelphia Beer" was made with egg whites.

Covering every ingredient and method in detail is better left to other books, but some patterns emerge when comparing these mid-1800s

recipes. The basic elements of brewing are there—sugar-bearing stuff must be added to water, said stuff must be boiled and then cooled and the cooled stuff must be stored away for a while for fermentation to occur. A few of the more professional recipes sound even more like something one would find in modern brewing—beer made entirely from malted barley, hops and yeast.

Things start to change in the recipes for smaller batches. The vast majority of these call for an addition of molasses to the brew, sometimes in addition to and sometimes in place of malt. The sugar content of molasses is high enough that it would certainly make a cheap, easy substitute for coaxing fermentable sugars out of malted barley. In some cases, like in the maple beer recipe, the molasses is also the chief flavoring component. It's here that it becomes clear why beer advertisers from colonial Charles Town, and Palmetto in the 1890s, explicitly stated when their beer was made from pure ingredients without additives. Home brewing is just professional brewing on a smaller scale, so where corners could be cut in one process they could certainly be cut in the other.

Another source of home-brewing recipes from the time is found in a small, anonymously written or collected book from 1863 called *Confederate Receipt Book*. The book was designed as an aid to homemakers in the war-torn and cash-strapped South to help make ends meet. It contains everything from home remedies to instructions on making soap to, of course, home brewing.

The handful of styles correspond to some found in *Early American Beverages*—ginger beer, spruce beer and table beer. Each of them calls for molasses only, no malt, in addition to various flavoring agents. One calls for treacle, a sugary syrup of which molasses is one type. With grain production dedicated to food for the war effort, and imports from the North stifled, malted barley was not something the Confederate housewife was likely to find at a local market.

This compilation proves one point beyond the ubiquitous use of molasses in home brewing. It proves that beer remained a staple part of the diet and lifestyle of the South even during wartime. Charleston had been and would continue to be a beer-loving city, so it's reasonable to conclude that beer was made in both brew houses and homes, consumed in both good times and bad.

THE ALE BOYCOTT OF 1890

In the late 1800s, labor unions were taking shape and learning how best to exercise their power, as well as how much power they actually had. One example of this occurred in New York but had ramifications all the way down to Charleston. Perhaps this is an example of the acceleration of information at the time more so than the rise of labor, but more importantly, it involved beer.

Tracy and Russell's Brewery was located in New York but had distribution in various places throughout the country, including Charleston. Allegedly, the brewery bosses attempted to decrease the wages of their workers, but the workers refused the decrease. As a result, the brewery locked them out. The Central Labor Union of New York and Vicinity got wind of this and sprang into action.

Among what was likely a mixed bag of tactics, they distributed flyers to the cities in which the beer was distributed, specifically targeting vendors in the area that sold beer from Tracy and Russell. One flyer that landed in Charleston named Boydd Brothers as vendors of "Tracy & Russell's Scab Ales and Porter," urging the working folk of the Lowcountry to "not patronize those liquor stores that sell this stuff, but leave them severally alone and have your friends do so too."

A number of Charlestonians took up the charge laid upon them by the far-off labor union. Workers from Charleston's Knights of Labor union spread the word and staged a local boycott of all vendors of Tracy and Russell products. After about a week, a small band of nine men escalated the situation. This "committee" marched together into the police station to ostensibly report a number of taverns for violations of the blue laws. Of course, they were just out to punish the barkeeps for continuing to sell the New York brewery's beer.

The list of taverns had been produced earlier in the day. The group visited each saloon asking for a drink without any pretense. If they were served the "scab ale," they ironically both finished it and paid for it but added the name of the offending location to their list. Once this was reported in the local paper, two of the nine men had a clarification printed that they did not drink a drop, as they were teetotalers.

All thirteen of the reported taverns were scheduled to appear before the judge the morning after their ambush. Each of them, members of the local Merchants' Protective Union, asked to have their cases heard by the

TO THE

Mechanics and Workers

OF

Charleston, S. C.

Your attention is called to the fact that Messrs.

BOYDD BROTHERS

are handling

Tracy & Russell's Scab Ales and Porter.

Now all honorable means have been resorted to in order to have them discontinue the sale of it, but without avail. Therefore we appeal to you not to patronize those liquor stores that sell this stuff, but leave them severally alone and have your friends do so too as those dealers are showing their contempt for the working people—the people they are making their living from—when they refuse to give up the sale of this ale and porter. The men in Tracy and Russell's Brewery were locked-out for refusing to accept a reduction in their wages. Now take this to heart and just consider what 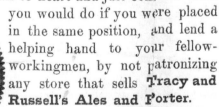 you would do if you were placed in the same position, and lend a helping hand to your fellow-workingmen, by not patronizing any store that sells **Tracy and Russell's Ales and Porter.**

This flyer from the Central Labor Union of New York and Vicinity was sent to Charleston targeting specific merchants who carried a beer from a New York brewery accused of slashing wages and staging a lockout. The local Knights of Labor in turn targeted Boydd Brothers and others in what would become a lengthy dispute with the local merchants' union. *From the Collections of the South Carolina Historical Society.*

city court. The stage was set for a battle of unions. The merchants' union hoped to get the case tossed out of court because the report came from the band of nine men and not from an officer to the law. They also pledged to "boycott the boycotters," meaning they would work to prevent those men from being hired by other members of their merchant union.

Other than newspaper articles, the remaining records of the legal scuffle consist of an affidavit by Bernard Boydd, the man whose company name appeared on a flyer from the Central Labor Union of New York. He alleged that the committee from the Knights of Labor was guilty of a conspiracy to "injure, harm, and wrong [Boydd] and others in their property and character." Boydd had dealt in beer from the New York brewery for nearly twenty years, and in his mind, to stop carrying it would be a financial disaster. He went on to say that the band of nine admitted to their conspiracy, as well as intimidation "by threats of injury."

Boydd was asked by the local paper to comment after the incident, but he declined. Instead, he provided a letter he received from Tracy and Russell regarding the matter at hand dated February 4, 1890. Here's where the story gets a bit fishy. The brewery's letter to Boydd stated that nineteen workers had walked off the job the previous December, and they had not returned. The brewery denied decreasing wages, staging a lockout or fighting the local union. Beyond this, it alleged that the local New York Central Labor Union attempted to coerce the brewery into firing four of its own men because they were not paying their union dues, but the brewery refused to do so. The union expelled the membership of those four, and Tracy and Russell believed the walkout was a result of this. With such conflicting stories, it's very unclear who was telling the truth, but the local laborers naturally bought the story of the New York union.

When the first band of alleged offenders had their day in court on March 11, eleven of the thirteen accused taverns were acquitted. Members of the committee were unable to identify some of the barkeeps, and the case began to look very flimsy. At the same time, the merchants had brought the union workers up on conspiracy charges. That did not stop the workers from continuing their charges, turning more and different taverns in each Sunday. As cases mounted, the defendants demanded jury trials, hoping to expose the boycotters as either dishonest or perpetrators of a conspiracy. This complicated things yet again, as the city's Ways and Means Committee would have to meet to establish payment for jurors, something it had not done in advance of the demands. Week after week, even into April, the Knights of Labor continued to report Sunday sales.

At this point, the trail goes cold. No further mentions of the boycott or counter-boycott appear in the remaining April issues of the *News and Courier*. Regardless of which side won the litigation, the uproar caused by a few taverns selling beer brewed hundreds of miles away is astounding.

Chapter 3

The Heavy Hand of Government

The information contained in this chapter comes in no small part from a book entitled The South Carolina Dispensary *by Phillip K. Huggins, which in turn acknowledges a debt of gratitude to* Ben Tillman's Baby: The Dispensary System of South Carolina *by John Evans Eubanks. These works serve as definitive sources on this piece of our state's history. While much of the coverage references liquor, the effects of the movement and the laws that followed would also affect beer, as taverns and retailers rarely carried one without the other.*

As the 1800s moved along, things were changing, as things tend to do. Charleston was becoming a bustling, cosmopolitan port city. The South was unknowingly making its way toward secession and war. In groups throughout the country, both above and below the Mason-Dixon, an unprecedented appetite for sobriety was growing.

THE RISE OF THE DRIES

The first waves of temperance fervor were sweeping parts of the United States by the early 1800s, but it didn't take hold in the South until the mid-1800s. While it's impossible to pinpoint, there are some theories as to what caused our delayed reaction. The southern states had a disparate population with fewer urban hubs, where the effects of problem drinking were made

obvious to all residents. There was a less affluent lifestyle in the South, which would afford one the luxury of high ideals. Whatever the reason, and despite the scarcity of historical records on the subject, the South lagged behind the North in clamoring for temperance.

South Carolina's first known meeting on the subject was held in Columbia in mid-1829. The outcome was the formation of the state's first formal temperance group. By the end of the year, it had a manifesto, officers and a name: the South Carolina Temperance Society. By 1832, the group had banded together with other like-minded, localized groups in the state, attempting to centralize their efforts and open new branches. The Temperance Society of Charleston had formed by now and was part of this cohort.

The growth of the movement over the next few years was huge. The centralized body came to be known as the State Temperance Society. This included twenty-six various local groups in 1838. That number grew to ninety by 1842. Membership in 1842 was about twelve thousand, but that jumped to about nineteen thousand the next year. The year 1842 also marked the formation of two new groups in Charleston—the Washington Temperance Society and the Young Men's Temperance Society.

LUSH LEGISLATION

The first state law regarding alcohol to pass since the law prohibiting sales to slaves in 1740 was also passed in 1842. It was an act requiring establishments to procure a license in order to sell liquor. While this law seems reasonable enough, some very silly alcohol legislation would soon follow. The year 1849 saw a law passed setting a legal minimum (yes, a minimum) of one quart per sale when liquor was sold, in addition to creating some hoops for barkeeps to jump through to continue serving on-premise.

It was around this time that certain counties voted to go "dry," preventing alcohol sales within their borders. New alcohol legislation went silent at this point due to the Civil War and remained silent until 1880, when a new law restricted the sale of liquor to only occur inside the borders of "incorporated towns." Just two years later, state legislation allowed these towns to individually vote out the sale of liquor within their borders. Many did.

The first full-bore prohibition bill in South Carolina was introduced in 1889 but did not succeed. The fact that the bill was even introduced indicates that, after a hiatus during the Great Unpleasantness, support for prohibition

had not only returned but had reached new heights. In the midst of this reprisal and the struggle for South Carolina to once again govern itself in the new postwar paradigm, a figure rose who would be key in shaping the state's handling of alcohol over the new few decades.

Pitchfork Comes to Power

Ben Tillman, a farmer living in Edgefield, was a political unknown outside of his community until he delivered a fateful address to the Agricultural and Mechanical Society of South Carolina in 1885. He transformed the otherwise mundane proceedings into a resounding rejection of the state's aristocracy and their exploitation of farmers. Tillman's scornful reference to these political elite as "the Bourbons" was a sign of things to come. Newspapers statewide picked up the news and printed some of Tillman's talking points, further ingratiating him in the rural parts of the state.

It should be no surprise that a rift was growing between Tillman's rural supporters and the urbanites who rejected his ideas. It should be even less of a surprise that his ideas were most roundly rejected in Charleston. The *News and Courier* wrote that his supporters "have no toothbrushes and comb their hair with their fingers." Tillman fired back that the "editor bestrides the state like a colossus, while we poor men, whose boots he ain't fit to lick, are crawling under him seeking dishonored graves." To the dismay of the paper, Tillman was sworn in as governor in 1890.

In the summer following his inauguration, prohibitionists managed to get a vote added to August elections to gauge the public's support for prohibition— essentially a nonbinding opinion poll. Prohibition "won" with 57 percent of the nearly seventy thousand ballots cast. Charleston was one of eight of the state's thirty-five counties in which prohibition lost. Regardless, Governor Tillman remained silent on the matter during the intense campaign of the prohibitionists over the summer.

The Formation of the Dispensary

The idea of a dispensary likely came to Tillman by way of a former resident of Athens, Georgia, where a dispensary system was already in place. T. Larry Gantt was then editor of the *Columbia Daily Register.* A dispensary system

was supposed to kill two birds with one stone by decreasing consumption of liquor and increasing intake into the state's coffers. At this time, with the local option law in place, nearly all tax or licensing revenue for alcohol sales was staying in the municipality where the sale was made. Intrigued with the idea, Tillman believed his numerous supporters in the state legislature would follow his lead upon meeting again in November.

It turns out that while the legislature was focused on the handling of alcohol, so many legislators had their own plans on how to tackle it that Tillman's supporters lost focus on his original plan. According to Phillip K. Huggins in *The South Carolina Dispensary*, opinions ran the gamut:

> *The result was a free-for-all of individual proposals, among which was a bill introduced by Representative Cole L. Blease, later governor and United States Senator, calling for absolute statewide prohibition; another by Representative S.A. Nettles, prohibiting selling or giving away liquor but allowing wine and cider for personal use; one by Representative Perry, to refer the whole question to the people at another referendum; another by Representative Childs providing statewide prohibition but with a provision allowing the sale of alcohol for medicinal purposes; and one by Representative Duncan modeled on the governor's recommendations.*

The variety of ideas led to the creation of a thirty-five-member House committee, which landed finally on Childs's notion of prohibition for everything but medicinal use. After debate and amendments, Childs's opinion morphed into the Childs-Roper-Nettles Bill. This called for a multi-tiered system, requiring a state-appointed party to dispense liquor to county permit holders, who would then sell to pharmacies. This was the beginning of what is now known as the "three-tier system," which requires producers to sell to distributors, who in turn supply retail and on-premise locations.

The bill passed the House but failed in the Senate and was thought dead by many, including capital city newspaper *The State*'s editorial board. However, the issue was destined to come back up within the same session. Stories differ on the cause, but Tillman took the bill under advisement and passed it directly back to the legislature, untouched except for his exclusion of "the medicinal clauses." This left only the outline for a state dispensary system. Despite Senator Smythe from Charleston mounting all the procedural challenges and delays at his disposal, the bill was ratified on the early morning of Christmas Eve 1892. Locals can rest assured that Smythe conceded defeat only after ensuring that a whopping ten dispensaries would be created in Charleston.

THE BEST-LAID PLANS

The design of South Carolina's dispensary system, as laid out in the 1892 bill, sounds like something from Soviet Russia. An appointee of the governor was to head up the commission charged with buying all the alcohol that would eventually get sold in South Carolina, "giving preference to domestic brewers and distillers." That alcohol would then be sold down to dispensaries at the county level, with a generous profit cap of 50 percent. A South Carolina State College chemist was even charged with testing the state-sanctioned alcohol for purity.

Counties could still opt to go dry by popular vote, so only the wet counties housed dispensaries. Conflicts of interest were avoided by legislating that barkeeps, hotel owners and the like could not apply to run a dispensary and by fixing a dispenser's salary. Home brewing and winemaking remained legal as long as the finished product was not sold. Vessel sizes for both beer and liquor had to be between eight ounces and five gallons.

Once word spread of the new law and its implications, opposition mounted from a few hundred tavern owners who met in Charleston to unify their efforts in striking it down. They planned fundraising efforts and legal challenges. Similar opposition was mounted by full-bore prohibitionists who were dissatisfied with the half measures of the new law. This backfired, as Governor Tillman issued a warning in addresses around the law's start date in mid-1893 that any opposition would end up in bed with pro-alcohol groups. The prohibitionists quieted down as a result, but the Charleston-based pro-alcohol bunch was as loud as ever.

Following research conducted by the governor and his dispensary commissioner, one Mr. D.H. Traxler, a gigantic operation was set up in Columbia to officially bottle and distribute all the legal alcohol in South Carolina. Meanwhile, individual legal challenges were mounting against the new state law. The proprietor of the Charleston Hotel personally petitioned for the right to continue selling alcohol directly to customers at his hotel. He was denied and "set out for Charleston, moaning that the Charleston Hotel would soon be no more."

Eventually, it became clear that there was no going back from the enforcement of the dispensary laws. With no recourse, retailers and barkeeps readied for the law to take effect on July 1 by having huge sales to profit on what would soon be illegal. June 30 proved to be a rowdy day in South Carolina, while the coming days and weeks were relatively sober and somber. That said, enterprising barkeeps wasted no time in opening

what would soon be known as speakeasies, and lawsuits continued piling up in state courts. Offenders also soon found themselves in court.

The first few violators were not prosecuted for selling liquor but for selling rice beer. This was a popular beverage due to its cheap manufacture, since the fermentable sugars came from a widely grown grain. Tillman soon included an allowance for the sale of beer outside of dispensaries in a list of proposed improvements to his system. The legislature heard his call for improvements and used them to pass a completely new draft of the law. Other changes included an allowance for visitors to bring small amounts of liquor into the state for personal consumption; allowances for hotels to sell liquor given a hefty bond paid upfront; and an interesting twist that allowed for the state to take control of local police forces in cases where their leadership opposed the dispensary laws.

VINCENT CHICCO, HERO OF THE DAY

The state's major newspapers acted as a very vocal mouthpiece speaking against the system soon after it took hold, even going so far as to encourage disobeying it without fear of repercussion due to its alleged unconstitutionality. The center of opposition was Charleston. While special concessions were made to ensure Charleston would have ten dispensaries, the citizenry opposed opening them at all. Tillman, not to be deterred, bluntly stated that he would "make the places that won't accept the Dispensary dry enough to burn." It's no surprise, then, that when it came time to make an arrest for a violation of the dispensary law, Charleston did the honors, and beer was the culprit.

Two weeks after enforcement formally began, Vincent Chicco, a local shopkeeper and businessman, was caught red-handed selling beer (more specifically, three beers) to a thirsty detective named R.H. Pepper in his saloon on Market Street. Chicco was well known and well liked in Charleston and had quite a storied past. At the ripe old age of fifteen, he sailed from Italy on a ship on which all his shipmates except himself and the cook died of yellow fever. He later moved to Charleston and became a policeman before setting up shop on Market Street. He owned adjacent three-story buildings at 83 and 85 Market, where he operated a hotel, a grocery store and a café. It was at this establishment that Pepper made his move.

The arrest did not happen on the spot; instead, enforcers returned along with the detective, warrant in hand. Chicco recognized the detective and

This September 1896 receipt is from the shop of Vincent Chicco, located adjacent to his café and/or illicit saloon on Market Street where a riot nearly erupted following his arrest for selling beer to a detective. His arrest was the first under the newly established dispensary system. *Photo by Timmons Pettigrew, receipt from the private collection of Jamie Westendorff.*

hurled insults at him. The enforcers cleared out the saloon and searched it, finding nothing but a small amount of beer and wine, which Chicco claimed was stock left over from before the law was passed.

Charlestonians, being a sympathetic folk who happen to love beer, sided with Chicco. The group congregating outside soon turned into a crowd, then to a mob, and the officers were provoked to the point where one drew his side arm. They were followed and berated as they left the scene. The lawmen got the mob's message, and Chicco was bonded out for only $500 after the incident finally ended. He was held up by local papers as the law's "first victim."

Chicco was not done defending himself. His arraignment saw another outburst against Pepper, described here by Harvey Teal and Rita Wallace:

> Chicco cursed Pepper during his arraignment hearing, because he and other constables invaded the room over the store occupied by Chicco's sick wife, threatening that if she did not open the door they would kick it in and take her to jail. Pepper had also pulled out his revolver and threatened to shoot Chicco, for which Chicco swore out a warrant for Pepper on charges of assault and battery with intent to kill.

Vincent Chicco's story made it all the way to the *New York Times*. His later unofficial title as "King of the Blind Tigers"—a term for illegal taverns that skirted the law by advertising for patrons to pay admission to see a nonexistent blind tiger and receive a complimentary drink in the process—removes any doubts about his position on the dispensary. He would eventually become an alderman serving over what was then Ward 8, running generally unopposed. When he passed away in late October 1928 at the age of seventy-eight, he had lived in Charleston for sixty years and remained lauded as "one of the most colorful and best known figures in Charleston."

CHAOS IN DARLINGTON

This was the first of many enforcement efforts that ended badly. By December, first blood had been shed by enforcers going after some bootleggers. The papers pounced on this incident to indict Tillman as a murderer and used the rare occurrence of warranted home searches as a flash point to add unrest over home invasion to the firestorm. Opposition gained traction as more blood was shed in February 1894, and some counties were even denied their fair share of dispensary profits as local policemen reflected the sentiments of their peers, refusing to enforce the law. As bad as things seemed, all this upheaval would pale in comparison to what would come next.

What would later be called the Darlington Whiskey Rebellion started when Governor Tillman heard tell that a judge in Darlington ruled the dispensary system unconstitutional. He dispatched a handful of extra officers there, and an already testy citizenry did the rest. Rumors began circulating of illegal searches, and soon a cadre of armed citizens was roaming the streets, ready to strike the officers down if they attempted anything resembling a raid. Telegraphs reached the governor's office, and reinforcements were ordered in from Sumter and Charleston. Word of the telegraphs reached the angry citizens of Darlington, who received their own reinforcements from surrounding counties. Once the reinforcements from both sides arrived, relative quiet returned, and no trouble occurred between them through the night.

Given the apparently false alarm, Tillman ordered the reinforcements to return home the next day by train. The remaining opposition group saw them off at the train station. Accounts vary on the exact details of what happened next, but the gist of it is that two youngsters with different viewpoints got in a fight. As they were separated, another youth uttered a horrible insult at one

of the officers, and the officer fired his weapon. After the chaotic shootout that followed, two men lay dead, two sustained serious wounds and a few others were hurt. The officers fled, while the mob scrambled for weapons before going after them.

A day of chasing, lynching and total disorder followed. The governor was off giving an address at Clemson while this occurred, and he was understandably shaken by the news when he returned. His plan was to employ all of his local, Columbia-area militias to quell the violence. Unfortunately for him, news had spread to Columba in the meantime, and the militias largely refused to follow his orders. Moreover, crowds were on hand ready to stop the militiamen willing to head to Darlington from leaving Columbia. In the end, none of these Columbia forces made the trip, as they realized they were sorely outnumbered and risked personal danger in challenging the angry mob by leaving.

The loyal General Farley made the rounds by train to collect militias in Sumter and Manning but had no luck. He didn't even bother with the scheduled trip to Charleston due to a defiant telegraph sent by the local commander to Tillman himself. Not every militia responded in kind though, and eventually twenty-seven arrived in Columbia in support of Tillman's orders. Many more sympathetic civilians came to town to show their support, armed with a variety of weapons and ready to head to Darlington in defense of the dispensary.

What they found was a quiet town, exhausted by the conflict and ready for it to be over. Chasing the constables had proven fruitless outside of a few run-ins, and they eventually made it back to Columbia. Temporary martial law was lifted, and the constables were tried and found not guilty. South Carolina narrowly skirted a civil war over the dispensary, and tenuous stability was restored at last. Tillman felt he had acted correctly and continued to support the system despite the events of those few weeks.

PITCHFORK LEAVES THE PICTURE

Tillman's victory in Darlington turned out to be short-lived. Less than a month after that, the South Carolina Supreme Court ruled the law unconstitutional. The premise of the decision was that by selling alcohol, the state sanctioned it as a legal good. In turn, the state could not legally prohibit its citizens from freely trading in it. News spread

Here we have a picture of "Pitchfork" Ben Tillman during his later years in 1910, while serving as a United States senator. He had been a member of the Senate for roughly fifteen years at this point and would die eight years later. *George Grantham Bain Collection, Prints & Photographs Division, Library of Congress, LC-B2-2744-3.*

fast, and celebrations were numerous and raucous. Charlestonians were thrilled, celebrating with a parade whose central figure was a whiskey barrel. Dispensaries were immediately closed and state liquor held out of circulation. Liquor licenses were distributed at a frenzied pace as old sellers and newcomers scrambled to take advantage of the situation.

Governor Tillman was biding his time, knowing that the makeup of the state Supreme Court was set to change soon and once it did, any further rulings would be in his favor. A sympathetic justice took his seat in July, and the governor reinstituted the system, knowing legal challenges would now fall on the side of the dispensary. In Tillman's defense, the legislature had the justice put in place, and he was scheduled to take that seat before the anti-dispensary ruling occurred. Folks who had jumped into the industry were angered but left with little choice but to shut back down. They were at least given the opportunity to export any remaining stock to other states.

The governor's term in office was ending when the legislature reconvened in November 1894, and he took the opportunity to offer some suggestions on improving the law. He highlighted the system's revenues of roughly $700,000, with roughly $100,000 in profit going to the state alone. Tillman left office in early 1895 but continued to participate in debates as a defender of the dispensary, eventually making his way to the U.S. Senate. The system as developed and enacted during his governorship remained fully intact until mid-1897.

While certainly not the focus of this book, a picture of "Pitchfork" Ben Tillman is not complete without mentioning the other of his two legacies based on the literature written about him: his support for hard-line "white supremacy" during and after Reconstruction. He worked to motivate and mobilize his fellow white male farmers (his close followers were called "Red Shirts") to keep the federally freed slave population an underclass. He actively campaigned to refuse or revoke voting rights for blacks and also touted the use of "force and fraud" to achieve or attempt to maintain his ideals. There was much resistance and fear in the South after the Great Unpleasantness, so this is not meant to demonize the man but only to round out the sources of his posthumous fame.

THE TWILIGHT YEARS

During the time soon following Tillman's departure from the governor's mansion, Charleston upped the ante of opposition by sheer numbers. Violators were numerous and flagrant. Popular opinion, further pushed against the law by the major newspapers, most notably the *News and Courier*, sided with the violators. Juries would ignore evidence of wrongdoing, throwing many cases of dispensary violations out completely. By January 1896, then Governor John Gary Evans found the situation dire enough that he used part of an ancillary law to seize control of the Charleston police force. They were successful in conducting over five hundred raids in the year to follow, but not much could be done to sway juries to convict. Enforcers' best bet was to avoid arrests, instead requesting injunctions from pro-dispensary judges. Violators continuing to sell alcohol could then be brought up on contempt of court charges and be punished without a jury getting involved.

Evans retired from office in 1897, leaving with a positive impression of the dispensary and his handling of the system. His successor, Governor William Ellerbe, spoke to the issue in his inaugural address. He noted the challenges of the system but supported it as a viable way to handle alcohol in the state. In an attempt to prove agreeable and show his support for local law enforcement, he asked the city council to sign a document stating that it would support dispensary enforcement so he could remove the state police control. Much to his chagrin, one-third of the council would not sign it, so state control remained.

Charleston would continue to prove a thorn in the dispensary's side in May 1897 when a U.S. Circuit Court judge in Charleston took issue with the law in a ruling. His take was that the state could not prevent the sale and consumption of alcohol imported from outside of South Carolina as long as it remained in its original package. By June, the first bars dedicated to "original package" sales had opened in Charleston, the first in the state. This resulted in a quick economic boom from liquor brokerages opening to newspaper advertising. The state could only enforce small infractions related to technicalities like business hours. Litigation occurred around what constituted an "original package," resulting in some changes in how out-of-state alcohol was packaged and shipped, but manufacturers were quick to respond to ensure that their goods continued to flow per the current law.

In the midst of this blow to the dispensary, Governor Ellerbe stuck with his conviction that local law enforcement should be used wherever possible. In October 1897, he not only removed state control of the Charleston police force, but he also disbanded the state enforcement bureau completely, only keeping people on to protect the dispensary buildings. Local law enforcement took issue with this, as they were forced to deal with dispensary violations normally handled by the state, all while violators became more flagrant than ever once word of Ellerbe's decision spread. Meanwhile, dispensary profits were tanking due to price competition from the private "original package" establishments.

All sides of the dispensary issue were waiting on a U.S. Supreme Court ruling on the circuit court case allowing for original package sales. But Ellerbe, facing a mountain of issues, lashed out against the circuit court judge in an address to the legislature in early 1898. He laid out two options: the state had to enforce the law as it was written prior to the circuit court decision, or it had to cut prices and abandon any hope of profiting in order to run private purveyors out of business. The speech turned out to be

unnecessary, as that May the U.S. Supreme Court upheld the dispensary system as written, casting down the dissenting decision of the circuit court judge. Governor Ellerbe was happy with the decision, but like Tillman before him, he afforded the right to sellers holding stock to export it and avoid prosecution.

Isn't This Book About Beer?

Beer was granted a serious exception that liquor did not enjoy in the dispensary system, something called "beer privileges." This was part of the redraft after Tillman's original recommendations. Phillip K. Huggins writes in *The South Carolina Dispensary* that, by this system, "the state entered into contracts with breweries whereby they were allowed to sell to blind tigers and private individuals on a royalty basis." This is how Palmetto and, later, Germania were able to legitimately continue business while the system was in place.

Beer was not only sold around the clock in hotels but often in the dispensaries as well. Employees would set up makeshift saloons so patrons would leave the bottles behind, and they could collect commission on the returns. The beer privilege system caused the heads of enforcement in Charleston to collectively resign in 1896, saying that it had reversed the progress they had made in enforcement up to that date. Finally, in 1899, beer dispensaries as a whole were ordered to close, though some still operated under the radar.

Death by Corruption

Employment with the dispensary proved to be a breeding ground for corruption, as many government offices dealing directly with commerce were (and arguably are). Jobs associated with it paid a fair salary, but more money was available if one was willing to entertain bribery from liquor dealers or would-be violators. Government officials wanted the system to succeed and made every effort to open as many dispensaries as possible. This effectively multiplied those jobs and, in turn, the opportunities for corruption. Inventories were short-counted, bottles were mislabeled to be sold for more than they were worth and out-of-state distillers were plied for

gifts. Even insurance fraud was involved. This likely permeated every level of the organization, but no governor's office was indicted for dispensary-related misconduct. Things only got worse when salaried positions were switched to commission paid on gross sales. In 1900, the legislature amended the law to close additional loopholes for corruption. These were half measures at best. The dispensary was a golden goose, and the state government was not ready to kill it regardless of the obvious corruption.

The revenue could not outweigh the graft forever, and in 1904, a bill was passed allowing county citizens to vote for total prohibition in their borders and, with it, removal of any dispensaries therein. Many did, despite the loss of collections that would follow. But violators being violators, a dry county would never be without illicit alcohol trade. Those looking to decrease consumption of alcohol would soon find that citizens of dry counties could simply travel to one with a dispensary and buy it there legally.

Finally, a committee within the legislature was tasked with investigating the dispensary in light of the corruption. It produced a thick document rife with evidence of a failing, irreparable system that was corrupted to its very core. The committee was eventually given judicial power, which only increased the amount of graft it uncovered. Unfair treatment of breweries was revealed, as dispensary employees and their cohorts would drink beer at the dispensary and then send "back the empty containers to brewers, saying the beer was 'bad.' The brewers dared not complain." The findings were made public by state newspapers. They were all too happy to expose the system as broken.

Public sentiment was solidified in the 1906 election, when candidates opposing the dispensary won the entire legislature, the governorship and even the position of attorney general. In early 1907, the state dispensary was killed, while counties were given the option to continue running their own. Twenty-one dispensaries remained, and their continued problems led to only six staying open after the next round of county votes in 1909. These few dispensaries drew in the business of drinkers statewide, leading to huge increases in revenue in each of them. Beer sales alone in these six counties were six times what they had been the preceding year. Seeing this, dispensaries were reopened, eventually rearing their heads in nine more counties.

Oddly enough, Charleston was the final stronghold of the dispensary system when total prohibition was brought to a vote. Their numbers were not enough, as the state passed a prohibition act in 1916 and was an early ratifier of federal Prohibition in 1918.

The Heavy Hand of Government

The dispensary system is nothing if not an odd and interesting footnote to our state's historical treatment of alcohol. The only other place to adopt the system statewide was South Dakota, and that state voted it out completely after only two years. In this way, maybe we were trailblazers. Unfortunately, the trail led to crime, greed and eventual prohibition two years before the rest of the country. As the kids say, "fail."

Chapter 4
The Dark Ages

These days, consumer products seem to be covered in obvious disclaimers telling folks not to eat super glue and to avoid sticking their faces directly inside a toaster. Here's my obvious disclaimer of bias: I think Prohibition sucked. It was the worst. You will find no other political positions taken in this book, but hopefully you saw that one coming. You're not reading the Charleston iced tea guide, after all.

It's widely accepted that Prohibition was a mistake, even by most contemporaries who worked to pass the only amendment to the U.S. Constitution written to repeal a prior one. The reasons are made even clearer in hindsight, from the boon it became to organized crime, to the rampant criminal behavior it created in people who may not have been criminals before its passage, to the skyrocketing rate of alcohol poisoning due to the consumption of unregulated swill.

From a beer perspective, it was devastating in other ways. It destroyed the brewing industry in America and ended professional brewing in South Carolina until the mid-1990s, but it also changed the face of brewing in the years that followed. The diversity in our nation's brewing industry prior to Prohibition was staggering, and that diversity was killed in its wake. It has taken the U.S. brewing industry roughly seventy-five years to recover that diversity. Even though it has returned in the number of breweries, the market share still lies overwhelmingly with huge conglomerates that mainly produce and market homogenized, uninteresting products.

Thanks a lot, Carry Nation.

THE BEGINNING OF THE TEMPORARY END

The story of the rise of temperance in South Carolina has already been told. The nation was undergoing a similar sea change in the opinion of alcohol, although at differing rates. While this was going on, beer was becoming exponentially popular relative to spirits. From 1850 to 1890, annual beer consumption increased by a factor of twenty-four, from 36 million gallons to 855 million gallons, while the population only tripled. By this time, beer was officially the most consumed alcoholic beverage in the country. This is due in no small part to the influx of immigrants from beer-centric countries like Germany and Ireland, as well as the advent of refrigeration machines. We experienced German immigration especially in Charleston, and families like the Döschers went on to open beer-making and ice-making businesses.

Unfortunately, Prohibitionists used the immigrants' beer-loving character to demonize alcohol through anti-immigration fervor, one of many tactics used to win the public over to their side. The original National Prohibitionist Party cranked up in 1869, adding to its platform issues like women's suffrage and public elections for U.S. senators (who to date were elected by the House of Representatives). The now-famous Woman's Christian Temperance Union was founded in 1874 in Kansas, the brainchild of hell-raiser Carry Nation, who took to saloons with axes. While she didn't do it single-handedly, her state was the first to prohibit alcohol in its constitution in 1881. Later groups included the Anti-Saloon League, which was founded in 1893 and went national in 1896. A chapter existed in Charleston and remained active at least until 1920.

A contemporary national group representing brewers was established as well. The U.S. Brewers' Association was founded in 1862 and worked to frame the industry in a positive light, counteracting the vitriol mounting against it. Its main tactic was to distance brewers from distillers by portraying distillers as a negative influence on the country while talking up the social benefits of beer. In 1866, the association claimed that "domestic misery, pauperism, disease and crime" were all consequences of the liquor industry and the consumption of its products. Adolphus Busch called its wares "the worst and cheapest of concoctions." Conversely, beer was called "liquid bread," and Busch called his own products "light, wholesome drinks." The association also threw its money behind anti-Prohibition candidates and political organizations, backing any platform that shared its goal of pushing back the call for enforced abstinence.

WHO ARE PROHIBITIONISTS?

Some men seem to think that the advocates of Prohibition are pious, well-meaning souls of no business sense, and altogether ineffective. But from a beginning in the hearts of our mothers, nourished by the Churches, Prohibition has developed and expanded until it includes today

THE FOREMOST MEN OF AMERICA

The Churches and the men of large interests came to the same conclusion: A MAN IS TOO FINE A SPIRIT to be clogged with alcohol.

Some Men are Prohibitionists for the Other Fellow

Having observed the effects of alcohol on many families; and having paid the price in their own offices, stores and factories for the other man's drinking, they now willingly forego their own indulgence, in which they probably were quite moderate, for the general good.

THAT'S GOOD BUSINESS. Don't you think so?

You say you can drink or let it alone. Many men can. But in truth, is that the rule or the exception? The law against murder was not needed for some men, either. They had no such impulses.

THE ANTI-SALOON LEAGUE OF AMERICA

Wishes the support of all those men who are ready to put the general welfare of their city, their State, and their Country, above their own tastes, and the opinions they may have held heretofore.

You Belong on This Side. Take a Stand

The Chairman for your County is M. G. WESTENDORFF. Stand by him.

This advertisement for the Charleston branch of the Anti-Saloon League appeared in the January 16, 1920 edition of the *News and Courier*. This was the day that national Prohibition became effective but four years after South Carolina passed it statewide. *Courtesy of the Main Branch of the Charleston County Public Library.*

Its efforts would prove futile. The U.S. Senate originally voted for what would become the Eighteenth Amendment in August 1917. The House followed suit that December. For the amendment to take hold, thirty-six of our then forty-eight states had to ratify it by 1924. That mark was hit in 1919, and all but two holdouts, Connecticut and Rhode Island, eventually ratified it. This may have been due in part to ridiculous charges from Prohibitionists that the German "beer barons" were funding propaganda for our World War I rival.

National Prohibition officially took effect on January 16, 1920. Some states, like South Carolina in 1916, had passed state prohibition laws prior to that, but doing so at the national level was the final nail in the coffin for legitimate alcohol producers.

FIGHTING FOR SURVIVAL

The statistical history of what happened to the nation's breweries is depressing. Germania had shut its doors due to bankruptcy around the time that South Carolina passed prohibition, but many of the nation's breweries were still

thriving. In 1915, there were an estimated 1,345 breweries operating in the United States; 185 of them were still open the day that Prohibition took effect, and they would soon diversify or perish.

There was still some illicit brewing going on. In cities with a serious organized crime presence, some continued to operate with impunity thanks to its protection. Al Capone was responsible for keeping a number of these running. If you weren't lucky (or unlucky) enough to have mob backing, your brewery needed to do something else. At the time, most breweries had some form of ice-making or refrigeration equipment, something necessary to brew consistently tasty lagers, a style very popular at that time, as well as transport and store beer. This led some to go directly into the ice-making business, while others reoutfitted for ice cream, cheese or something otherwise suited for their refrigeration systems. The unused bottling equipment led others to enter the soft drink market.

As you might expect, a great many failed, Germania being an example of this with its "crystal ice factory." The big players at the time were the ones with the cash flow and scale to survive Prohibition. In addition to food products, they entered the malt syrup market. This product, known as "extract" to modern home brewers, could be boiled, cooled and paired with yeast to create homemade beer.

It was legal to sell the syrup since it wasn't alcoholic, and it helped the large ex-breweries survive. The home-brewing process itself was made legal when the Volstead Act was passed in 1924 to sharpen the language of Prohibition, though only up to a very small percentage of alcohol, so the malt syrup producers remained in the clear from national enforcement. Shops opened specializing in the product and other home-brewing supplies. There were trade associations and even a magazine. In 1926, Anheuser-Busch reached sales of six million pounds of malt syrup annually, a number that would remain steady until repeal occurred seven years later.

FAILURE AND REPEAL

National opinion never turns on a dime, but Prohibition is maybe the closest it's come. Once it became effective, violations were rampant. Everyone has heard the romanticized stories of speakeasies with secret code words, bootlegging mobsters and bathtub gin. But there were some very non-romantic effects as well. In the first year of Prohibition, there were 1,064 known deaths from

alcohol poisoning. Five years later, the number quadrupled. It's estimated that over 50,000 occurred in 1927. Other deleterious effects like blindness and paralysis were occurring as well, all due to people consuming "alcohol" from unknown sources. Impurities were likely packed into some of them, while others probably weren't even ethanol.

Alcohol was sprayed into legal "near beer," which had about 0.5 percent of alcohol by volume, to increase its alcohol content. This produced what was called "needle beer" since a hypodermic needle was often used to do the deed. This sounds like a likely source for some poisonings, as well as a disgusting travesty for the poor beer's flavor.

By 1926, public opinion polling had turned against Prohibition, and the nation was ready for repeal. Groups like the Anti-Saloon League were losing credibility by supporting ideas like making alcohol even more poisonous to deter use, something no one had an appetite for after the exploding death toll. Prisons and courts were beyond backed up. Corruption in enforcement agencies was rampant, a lesson South Carolina had learned all too well during the dispensary years. The Great Depression would increase drinking, illicit production and profits for criminals. Once again, larger circumstances affected the public view of alcohol.

The first anti-Prohibition president, Franklin D. Roosevelt, was elected in 1932. By December of that year, a resolution for repeal was in Congress. It passed both houses of Congress in February, and Utah was state number thirty-six to ratify the amendment that December, a much quicker process than when Prohibition had started.

Roosevelt signed the Twenty-first Amendment at 7:00 p.m. on December 5, 1933, and the nation started partying. After consuming one and a half million barrels, the next day there was a shortage. At least the thirteen-year, ten-month, eighteen-day nightmare was over for most states. Kansas, Oklahoma and Mississippi remained dry for some time after that, with the latter finally legalizing alcohol again in 1966.

The Aftermath

With alcohol—and, in turn, beer—made legal again, the nation found itself with more demand than it had supply for some time. Most breweries were shut down during Prohibition, but the larger players were left to return to their original business. Only thirty-one were open even three months after repeal.

This led to a serious seizure of market share. Where many Americans used to have local or regional options for beer, now many didn't. Advances in refrigeration and transportation had been made. Coupling that with the acquisition of many defunct breweries, the large players became even larger. By 1935, only five brewing companies had 14 percent of the market share of beer. This didn't bother most drinkers. Those who had continued to imbibe during Prohibition had largely switched to liquor due to its relatively small size and weight for the same alcohol content. The nation had lost both its supply of and demand for local beer.

World War II had an even tougher effect on our beer palates. With many of the nation's men off fighting overseas, companies—breweries included— had to market more of their products toward women. This caused the increase in production and brand development of fizzier, lighter versions of the refreshing lager that the few remaining breweries were producing. Rice and corn had already found their way into American-made lager, as brewers worked to make the heavier German version more accommodating to Americans during their rise in the late 1800s. To lighten the beer, more of these "adjunct" grains were added in favor of traditional malted barley, and light beer was officially born.

This is not meant to be sexist in any way, but the breweries found success marketing lighter beer to women at the time. When the men returned, they were thirsty but largely undiscerning, so they jumped on the light lager bandwagon as well. Fast-forward to 1958, and those same five companies had a 31 percent market share.

The nation really remained in the beer doldrums through the next two decades, at least in terms of flavor and choice in the marketplace. This is not to say beer was bad business—it was anything but. Sales had regained pre-Prohibition volume by 1970, but the product had become homogenized and dominated by so few competitors that very little interesting, local or regional development was happening. Consumption was driven by branding and marketing, as the breweries scrambled to one-up each other's brand identity as opposed to their product, ostensibly. They had resounding success on the bottom line. Fast-forward to 1980 and only forty-eight breweries were open in this country. Go far ahead to 2009, and the big five brands had dropped to being owned by three companies, which together had 80 percent market share.

CARTER TO THE RESCUE?

The repeal of Prohibition had not explicitly made home brewing real beer legal again. There was an effort to do so for both wine and beer, but beer was left out in the cold. Charlie Papazian—home-brewing guru and author, among other things—asserts in the documentary *The American Brew* that it may have been due to a simple clerical error. This was rectified during the Carter administration. With home brewing made legal in 1979, a supply of ingredients and information on how to brew would soon be available where none had been before. It was a renewed interest and revolution in home brewing that led to the development of many of America's post-Prohibition small breweries.

A beer writer who also spent time covering the microcomputer industry soon coined the term "microbrewery," which today seems long gone in favor of "craft brewery," but those are just semantics. Regardless of label, these innovative home brewers enjoyed their own products much more than what they found in stores, combined that sensibility with a little entrepreneurial spirit and started what would become a national movement.

California breweries were the first to jump in. Very early entrants like Anchor Steam and New Albion even predated the home brew law, with Anchor purchased by Fritz Maytag in 1965 and New Albion opened by Jack McAuliffe in 1976. Soon, Sierra Nevada joined the fight in 1980, and over the course of the next few decades, many others would follow suit. The nation's brewery count would grow to 400 by 1995. Finally, in 2009, we broke the pre-Prohibition record. As of 2010, there are 1,753 operating in the United States, the majority of which are producing craft beer, though the vast majority of beer sales still belong to the light lagers of the "big three."

The story of the national boom in craft beer is an interesting one, a true David and Goliath tale full of legal wrangling, leveraged assets and probably a lot of sleepless nights. However, you're here to learn about beer in Charleston. As is often the case, South Carolina took a few years to catch on to the trend. In 1994, we would see the first post-Prohibition brewery in the state open here in Charleston.

Chapter 5

The Renaissance

T he year 1994 would prove to be a landmark one not only for Charleston beer but for South Carolina beer as a whole. After decades as a beer DMZ of sorts, it was finally time for something interesting to occur. As usual, the spark for change started with people with vision willing to take risks. In this case, they were two windsurfers who wanted to bring a piece of Oregon back home.

PALMETTO, TAKE 2

Ed Falkenstein and Louis Bruce met toward the end of the 1970s, a time when craft beer was just beginning to rear its foamy, delicious head. Ed was a transplant from Frederick, Maryland, and had a background in chemical engineering, while Louis was a Charleston native with a background in biology. They were brothers in science if nothing else. The two lived in Charleston and were both into windsurfing, often sharing a few beers after a day on the water. Unfortunately, the only beer usually available was fizzy, yellow and almost tasteless—that is, until they visited Oregon.

A trip to the Columbia River Gorge would change their lives forever. They went for the windsurfing, which was terrific in the gorge thanks to the clashing weather patterns of the dry desert climate to the east and the moist forests to the west. The area was having a tough time economically, with

its main agricultural products—lumber and fruit—not doing too well. As windsurfers discovered the ideal conditions, a small tourism industry began building up around the sport. As a result of that, or despite it, Full Sail Brewery, one of the earliest entrants into the craft beer scene, established itself on the banks of the river.

Ed and Louis were enamored with the beer, which they enjoyed either after a day on the water or in lieu of it when the weather turned bad. The conversations ran from how great it tasted, to how they wanted to share it, to how they wanted to be able to drink something comparable back home. They had a full view of the brew works from their usual spot on the deck, and Ed realized he was familiar with much of the gear they were using from his work—filtration machines, pumps, etc. Their vision gained clarity there: it was time to open a brewery in Charleston, and they would be the ones to do it.

Starting Up

The business plan was cobbled together in their spare time over a couple of years. They enlisted the help of a well-established local distribution outfit, still their distributor to this day, for market research, as only a few "craft" brands were available in the area at that time. The pair also visited other breweries, including Wild Goose in Salisbury, Maryland, to share ideas and get a better sense of the challenge they were facing.

And so they set out to open the first brewery to operate in South Carolina since Prohibition ended. Some research brought the original Palmetto Brewing to their attention, and they chose the name as part of continuing the story of beer brewed in the Lowcountry. Funding proved to be an issue for obvious reasons. The bank they approached for financing placed them into the high-risk category along with two farm start-ups: one for clams and one for ostriches. They eventually secured funding through a combination of their success with the bank, outside fundraising and their own savings and ended up with a $700,000 investment. After location scouting, they landed on Huger Street, where a vacant brick warehouse was shown to them by a friend in the real estate business. This would be the permanent home for the new Palmetto Brewing Company.

While working on the brick and mortar, there were also regulatory hurdles to overcome. The state's laws in 1993, as would prove true again

and again in the future, were just not up to snuff when it came to beer. Lawmakers first told them that opening a brewery was outright illegal. It turns out this wasn't true, as long as they sold only through a distributor per the state's three-tier system. There was just no precedent for regulators to use. The entrepreneurs found themselves filling out forms created for restaurant liquor licenses that had been scratched through and corrected by hand in an attempt to fit them to a brewery. While the federal government was better prepared to handle them, the process still involved everything from personal background checks to a personal visit from a (friendly) ATF agent to help with the paperwork. Somehow they navigated the red tape, and the brewery was legally a "go."

Equipment installation was next, most of which was done by Ed and Louis personally. The welding, however, was left to the good men at Noolan's, the Canadian brewing equipment company where their tanks were sourced. That left the extremely important market analysis. Ed and Louis were truly flying blind, with no real idea what the market would be since the state hadn't housed a brewery in roughly seventy-five years. No amount of confidence could get their beer to market without a distributor, but they made the wise decision to involve theirs in the planning stages of the brewery. Luckily for everyone, locals were ready for a change. In its first year, Palmetto would brew and sell 1,500 barrels, or about forty-five thousand gallons of beer, a number that would double by 1998.

(It's worth noting that one Mr. Les Addis, and later one Mr. David Merritt, were both early employees of Palmetto Brewing. They appear in supporting and costarring roles, respectively, in the next chapter.)

The Starting Lineup

In April 1994, Palmetto Amber made its debut. The brewers first made this on their pilot system with an eye (or mouth) for something that the state's light lager–soaked palate would enjoy as an introduction to the possibilities of craft beer. There's no need to describe the color of Palmetto Amber; the name takes care of itself. There is a great, round malty essence to this beer, typical of the style but done very well. The hops serve only to accent the malt, comfortably playing second fiddle throughout. The beer takes on a mild sweetness after a few sips and finishes with a bitterness that takes shape in the aftertaste.

They had developed their pale ale by this time as well but thought it too bold of a choice for a first run. Palmetto Pale Ale is the most hoppy of what would become their four year-round offerings. The color approximates a dull orange, but it pours just as clear as a lager might. The smell indicates some grapefruit-like hop content, which is affirmed as soon as it hits your tongue. Compared with today's hop-saturated craft beer market, this guy is balanced, but it was surely a study in bitterness when it debuted in the mid-'90s.

Soon after, a lager followed. Palmetto Charleston Lager is the lightest of the bunch and probably the most accessible to the uninitiated. Its totally clear, straw-hued pour is standard for the style, the light version of which still dominates the American macro-brewing industry. Unlike its lighter counterparts, this is a full-bodied lager with some character. The malt is the dominant force here, with a slight hop bite mingling with a mildly crisp finish. Charleston Lager is a gateway beer, paving a clear path for light lager drinkers everywhere to try something locally brewed and flavorful.

The last of the quartet was originally called Palmetto Porter. This one was quite controversial at the time, as its dark hue was really going to push the limits of the uninitiated drinker. Doubts were dashed soon enough, and the porter has remained a year-round style for Palmetto ever since. Recently it morphed into Palmetto Espresso Porter, as the brewery imbued the brew with fresh coffee from its Huger Street neighbor, Charleston Coffee Roasters. The two businesses share quite a bit, and after a long day of work, the coffee crew would sometimes drop a shot of their espresso into a glass of Palmetto Porter. The brewers realized this was good stuff, and so the idea was born.

A custom blend of beans is roasted about two days before the coffee goes through a cold brewing process. The cold brewing cuts down on the acidity of the end product, and that infusion is added to the porter in the brew kettle. This is an excellent introductory coffee beer thanks to its balance. It pours with the recognizable darkness of a porter, an extremely deep, dark, but translucent brown. The coffee is present and pronounced both in the nose and the taste but is not overwhelming. Nor is the roasted character of the porter too intense or dry to turn off your average beer drinker.

Those four year-round offerings remain Palmetto's core product line to this day. It's perhaps that stability that kept the brewery in the minds of consumers early on and established it as a staple for seekers of local brew. Even though the styles remain stable, the recipes are often tweaked.

Palmetto beer continues to be very much a handmade product, and the brewers will subtly play with recipes over time to suit their tastes or the tastes of their consumers.

Ingredients originally came from all over, with hops and malt coming from the West Coast and the Midwest, respectively. Their water, which is an often-overlooked contributor to beer's flavor profile, comes from the North Edisto River, ensuring every beer Palmetto makes is imbued with something local.

Packages, Labels and Taps (Oh My)

Palmetto was a draft-only operation for its first three months while a bottling line was installed. The brewery took the time to try to stake its claim in local bars, especially going after those that carried imports. American craft beer was not exactly a "thing" yet, so imports were the best available alternative. Little did most consumers know that imported beer was destined to be old. Between the time it took to actually import it and the large quantities required for distributors to buy it, it was rare that one would taste freshness

A collection of kegs at Palmetto Brewing Company, filled and ready to hit the taps. The stickers are used to easily identify the kegs so they can be returned and refilled, but the lettering harkens back to the old Palmetto Brewery. *Photo by Chrys Rynearson.*

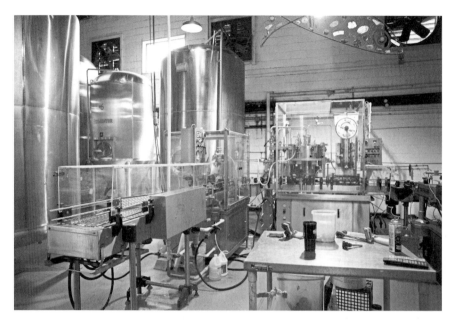

A shot of the bottling line at Palmetto Brewing Company, located at the far end of the brewery's main floor. It is positioned at the natural end of the brewing process, making it extremely efficient compared with the breweries of old with separate buildings for bottling. *Photo by Chrys Rynearson.*

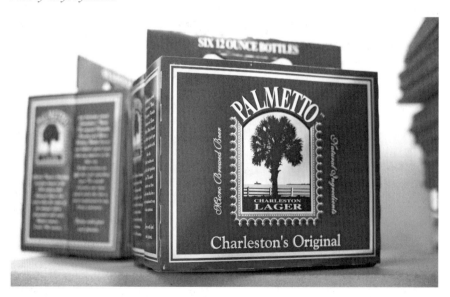

The six-pack packaging for Palmetto Brewing Company centers on its classic palmetto tree logo. The green background is specific to Charleston Lager, as other varieties have different color schemes. The tree remains the common touch point for them all. *Photo by Chrys Rynearson.*

from an import tap at the time. Palmetto provided not only a locally made alternative but what was probably a much tastier one.

Once the bottling machine was installed, the pair went to market. They also learned how hard it is to run a bottling machine. With so many components going all at once, and at such speed if everything is singing, a whole lot can go wrong. It's an intense process that requires concentration throughout. Ed also found it to be an outlet for his scientific side, as they fought to control the amount of air that was trapped in each bottle. Too much air would hurt the shelf life of the beer by increasing the rate of oxidation. His perseverance eventually got it to manageable levels, but bottling is no less challenging today than it was when they started. So appreciate those bottles, people!

Creating the Palmetto label was also an intense process. Think back to the early to mid-1990s and you'll notice, among other things, an utter lack of photo editing software. Ed and Louis took hundreds of photos of palmetto trees and spent countless hours at a kitchen table cutting, pasting and trying to find something that would reflect their sensibility and the history they were continuing with their brewery. A palmetto tree from Fort Moultrie was the winner, and it was superimposed on a Battery scene to get Fort Sumter and Morris Island in the background. The labels for the year-round beers continue to use this scene.

Recently, the tap handles have taken a turn for the artistic. If you've seen a brightly painted palm frond that looks like some kind of 3-D concert poster sticking out from a bank of taps, you've seen a new Palmetto tap handle. Ed often collects these while walking the Awendaw trail. They are then coated and finished, and a local artist puts the finishing touches on them. While it's a labor-intensive process, like most things Palmetto does, it creates a unique product. Each tap handle is different, just as each frond is different. Many, however, include the brewery's motto: "Enjoy with Food and Friends."

A Time for the Seasonals

Recently, Palmetto introduced the Bocat line, an umbrella name for a number of rotating seasonals. The brewers are animal lovers, and the name came from a stray cat that often hung around near the brewery. A local artist created a painting of the cat, and eventually it became the label for these beers. As part of Palmetto's community involvement, a dollar from each

case sold goes to the Charleston Animal Society, and you'll find bookmark-shaped brochures for the CAS tucked into each six-pack. The brewery's work along these lines also includes giving spent grain to local farmers and donating beer to a number of charity events each year.

Early members included Chocolate Bock, an interesting experiment in chocolate-izing a lager, and Watermelon Wheat. The watermelon brew was an attempt to get a locally grown product into a beer, and the general consensus was that watermelons are awesome. It started as a watermelon lager, but that didn't quite work out, and wheat was the eventual winner after a test batch was well received at a beer dinner. When that small batch was scaled up to a full-production batch, the brewers found it would take fifty watermelons to make. Some friendly folks in the dairy business lent them a tri-blender, a device normally used in cottage cheese production (yes, they cleaned it first). They still had to cut the rinds off all fifty by hand, which was no small feat.

This author's personal favorite, however, has been Hop Harvest IPA. This is Palmetto's version of "fresh hop ale," a style made with still-wet hops that have to be transported from harvest to kettle in less than forty-eight hours to avoid spoilage. It was a trip to an actual hop harvest in the Yakima Valley that spurred this idea, as the hop harvest in the area is celebrated with a festival where local brewers make fresh hop ale.

The process of producing fresh hop ale—or wet hop ale, as it's also called—ranks somewhere between difficult and insane. A kettle full of wort (unfermented beer) must be constantly at the ready during a certain window of time. The exact shipping time depends on the harvest, which depends on the weather. Once harvested, the hops must be sealed and sent via overnight delivery across the country and put directly into the waiting kettle. The result is an extremely grassy, even juicy, hop character. Palmetto's was the first wet hop beer commercially brewed in Charleston, perhaps even the state, and can stand its ground with other fresh hop ales from around the country.

The newest edition of the Bocat line is a springtime Extra Pale IPA. The recipe is modeled after Hop Harvest IPA but uses regular, dried hops. The hop blend used in this beer is a new one called Falconer's Flight, named after a brewer who died of cancer. Proceeds from sales of the hops go to brewing and hop-farming education. If successful, the IPA may even become the fifth year-round Palmetto beer, the first since the porter was added to the lineup roughly fifteen years ago.

Seventeen years later, Palmetto keeps doing its thing, quietly churning out hand-crafted beers from its home base, tucked away on Huger Street. While it started in a relatively dry time for craft beer, it continues to move forward in what appears to be the best climate for craft beer the area has ever seen. Here's to keeping the faith!

Brewpub Beginnings

Palmetto established that there was demand for craft beer in Charleston. Soon, another establishment would open to further drive this point home. Southend Brewery and Smokehouse started bringing house-made beer to market on East Bay Street in mid-1996.

Southend's original location opened in Charlotte in 1995, named after the street where it was located. Charleston was the second opening of what would become a five-location chain, with two more opening in North Carolina and one in Florida over the coming years. The Charleston location is not only on East Bay Street in an area with high foot traffic, but the gorgeous three-story building is over 130 years old. The aim of all the locations was the same: to bring craft beer production inside a restaurant where diners could see the brewing in action and taste the outcome at the table.

For once, our state's beer laws did not create significant obstacles for this establishment, but they do clearly define what a brewpub can and can't do. In exchange for being able to serve directly to the public, brewpubs trade away the ability to distribute anywhere outside their doors and the ability to brew more than two thousand barrels per year. This was not a deterrent for Southend, but you can see where a brewpub with particularly high aspirations might want to open its doors in a more beer-friendly state. But I digress.

The Charleston location of Southend opened with three positions in the brewing department—one brewmaster and two assistants. Demand from the public was high immediately, and the crew of three worked at a breakneck pace to keep the tanks packed with beer. Southend produces six year-round brews to this day, with one or two rotating seasonals that are up to the brewmaster to choose. It was during these early multi-brewer years that David Merritt would cut his teeth at Southend. As mentioned before, more on him later.

While Southend was making its mark in Charleston, a young beer enthusiast from Philadelphia named Ahren Warf was attending Furman

University in Greenville, South Carolina. His familiarity with brewing started very early, as both his father and uncle dabbled in home brewing. He began chipping in on the bottling process at ten years old, but brewing was never a career aspiration. He got a job in Greenville at a local brewpub called Blue Ridge Brewing, where he worked for three years while pursuing a degree in psychology.

Ahren eventually made his way to Charleston working in the biotechnology field, but it soon became apparent that it was not something he'd like to do for the rest of his life. After quitting that world, he got a job as a waiter at Southend in 2005 while formulating a grand plan for what to do in his professional life. He made fast friends with the brewmaster, who found Ahren to be a great help and resource thanks to his experience at Blue Ridge.

Eventually, the brewmaster made his own life-altering decision—he wanted to move back to Canada. Ahren recognized the unforeseen opportunity and stepped in to fill his shoes in 2006. He's been the brewmaster ever since, thanks to that series of happy accidents. Ahren inherited all the recipes Southend had been using since its inception, taking his time to learn the brewing gear and the ins and outs of the individual styles. The brewing

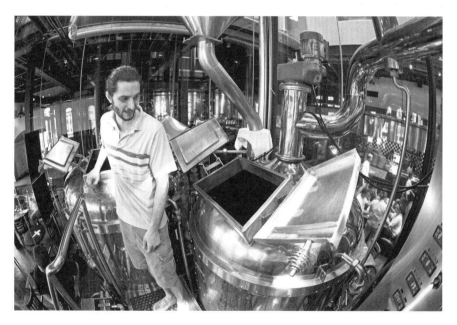

Brewmaster Ahren Warf explains his brewing process while overlooking the brew house at Southend Brewery and Smokehouse. The brew house is located in the middle of the main floor, encased in glass walls so patrons have a full view of brewing in action. *Photo by Chrys Rynearson.*

The chalkboard Southend Brewery and Smokehouse used to display details about its tap list. Note the new names located on the far left, as well as information on the beer's age and alcohol level. Pay no attention to the right side of the board; that's fodder for another book. *Photo by Chrys Rynearson.*

system at his fingertips was a serious improvement to the system he had learned on in Greenville. The ten-barrel brew house allows for twenty barrels of output on a long double-brew day, and five twenty-barrel fermenters are constantly feeding the seven serving tanks that lead to the bar.

In late 2009, Ahren began reworking the recipes. The business wanted to keep the signature styles that its customers had grown to love, so no year-round styles were changed, but he was still able to make his mark on each of them. More recently, the year-rounds have received proper names like Castle Pinckney Pale Ale and Rip Tide Red. The rotating seasonal tap is where Ahren can push the envelope the most and brew a variety of styles, which have included everything from an amber ESB (Extra Special Bitter) to a double IPA to a brew made with pilsner malt, ale yeast and a lemongrass infusion.

With the recent change in ABV laws (more on that in later chapters), the palette Southend has to work with has expanded even more. Time will tell whether it will change some of its year-round styles to take advantage of this, but as long as it is open, you can grab a pint brewed only a few feet away.

HOME BREWING, TAKE 2

There are many aspects of the craft beer "scene" these days. You've got breweries, pubs, retail shops and the consumers who frequent all three. An oft-overlooked, but very important, part of the culture is home brewing. Once brewing beer at home became legal federally, the hobby sprouted and underground brewers surfaced. Home brewing was the catalyst that drove and continues to drive innovation in the professional brewing arena, with basically every professional brewer having started out brewing at home.

While home brewing might sound like a hermetic exercise in quiet science, it can be as social as the other aspects of beer culture. Enter the home brew club: a gathering of like-minded folks sharing ideas, recipes and varying levels of expertise and working to move their beloved hobby forward. Charleston is no stranger to this phenomenon. In fact, there was an active home-brewing club established here well before the proverbial cap was popped. The aptly named Low Country Libations was meeting regularly in the late 1990s, with roots stretching back at least a few years before that.

Brent Brewer, current president of the club, began attending meetings in 1998. Back then, the crew met monthly on the second floor of Southend Brewery and Smokehouse. Meetings generally included a rotating cast of about forty to fifty heads, often going from a loosely organized roundtable to more of a cordial party atmosphere. It was during one of these meetings that the name was proposed on a whim, and it stuck ever since.

Around that time, there were two key elements that kept the club active and growing. First, there were dedicated home-brewing shops in the area. Stores like Charleston Beer Works on Savannah Highway (not to be confused with the current bar of the same name) and Happy Dog in Mount Pleasant served as supply houses and connection points for the club before online stores had much traction. Brent worked in one of these shops for a short time, further cementing his interest and interaction with local home brewers. Secondly, the state still only allowed a maximum of 5 percent alcohol-by-weight for beer. For real beer lovers who didn't want to travel across state lines to get the best that craft beer had to offer, home brewing was a logical alternative.

Unfortunately, a lack of demand for the dedicated shops did not allow for any of them to stay open. Today, there are no home brew supply stores in the area. COAST Brewing (more on it in the next chapter) ran a small

shop as part of its brewery in the early days, opening a few hours a week with limited supplies but lots of free knowledge. It, too, had to close that part of its operation due to lack of interest. The best-known and longest-lasting store left near Charleston is Bet-Mar in Columbia, where Brent bought his first home-brewing kit, a clone of a popular Czech pilsner.

Since the late '90s, Low Country Libations has seen decreases and increases in interest. The local shops closing hurt its membership due to a lack of ingredients. The U.S. hop shortage in the mid-2000s didn't help either, as the price for the key ingredient skyrocketed to as high as $100 per pound. On the other end of the spectrum, the Internet worked in its favor, as information on brewing became easier and cheaper to acquire and ingredients became easier to procure. Once the cap popped and the craft beer "boom" started rushing into the area, interest was boosted once again. However, throughout the waxing and waning of interest, Brent and a core group of members have remained dedicated and kept the club alive.

That core group has also worked to bring more organization and order to the club during their tenure. Part of this involved putting general structure to the club, including collecting dues, issuing membership cards and the like. Beyond that, it became an official competing club registered with the American Home Brewers' Association and, more recently, a participant in regional competitions with Carolina Brewer of the Year. Each club (generally one per city) holds competitions throughout the year. These competitions can be quite complex, including blind judging often from certified judges and a point-based award system that recognizes both the individual brewer and his or her club. Home brewers pay to enter their creations in the contest to help cover the cost, and a good time is had by all.

A good time is also had by all during the club's meetings. The membership numbers about forty to fifty people, which is relatively small, even for home-brewing clubs in the Carolinas. However, this ensures that in a given three-hour meeting, everyone in attendance tends to get his latest creations sampled by everyone else, leading to full participation and more constructive feedback. Meeting places rotate throughout the year from the homes of members to local beer hot spots like Palmetto, Southend, COAST Brewing and others.

If you think you might be interested in brewing your own, President Brewer offers up the following pieces of advice. Home brewing requires patience, some willingness to invest in the hobby (which starts cheap but can get more expensive as interest grows), attention to detail and a sense of cleanliness. Given those basic ingredients, it really is a simple affair that

anyone can try. The hobby can be quite fulfilling as you learn about the scientific aspects of brewing and continuously work to improve your brews, and there's the perk of drinking them at the end. And, of course, don't be embarrassed to join a club!

One final word of advice: asking a home brewer about his or her favorite home brew is not unlike asking a parent who his or her favorite child is. There is no right answer.

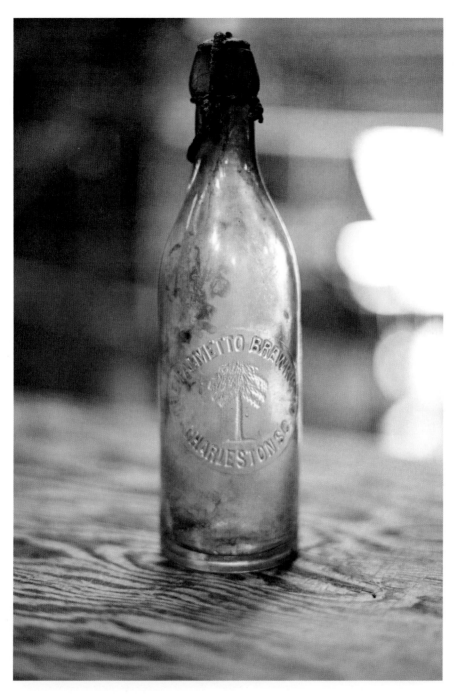

A very rare bottle from the original Palmetto Brewing Company, whose seal remains preserved over one hundred years later. *Photo by Chrys Rynearson, bottle from the collection of (the modern) Palmetto Brewing Company.*

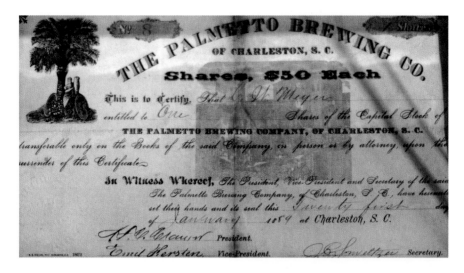

An original stock certificate from the old Palmetto Brewing Company, dated 1889. The certificate belonged to someone named Meyer but is signed by the then-proprietors, Cramer and Kerstin. *Photo by Chrys Rynearson, from the collection of (the modern) Palmetto Brewing Company.*

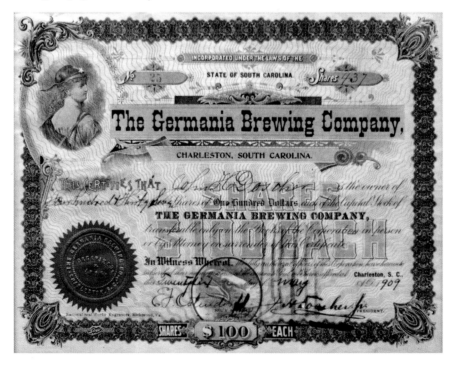

This colorful, elaborate stock certificate from Germania Brewing Company belonged to J.H. Döscher himself, valued at $100 in May 1909. *Photo by Chrys Rynearson, from the collection of (the modern) Palmetto Brewing Company.*

Fermenters of varying sizes are positioned along a wall on Palmetto Brewing Company's main floor, numbered for easy reference for visitors interested in the brewing process. *Photo by Chrys Rynearson.*

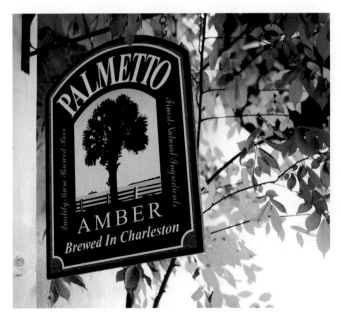

Palmetto Amber, the first commercial release from Palmetto Brewing Company in 1994, is commemorated in this sign hung outside the brewery's door at 289 Huger Street. *Photo by Chrys Rynearson.*

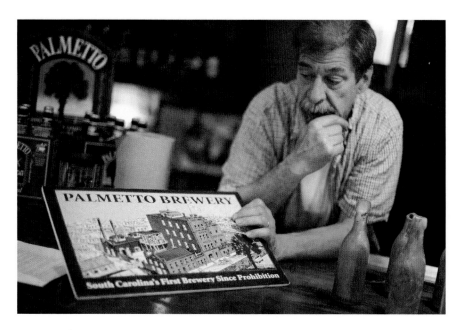

Ed Falkenstein, co-owner and co-founder of the modern Palmetto Brewing Company, shows off a large, colorized reproduction of the old Palmetto Brewing Company's diagram as displayed on its original documentation. *Photo by Chrys Rynearson.*

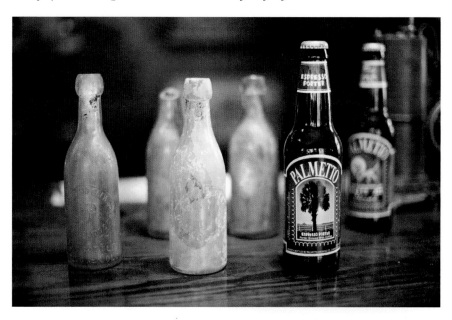

Bottles from both the old and new Palmetto Brewing Companies are put side by side for comparison. *Photo by Chrys Rynearson.*

The glass-walled brew house at Southend is shown here, including the small silo that feeds grain into the system from overhead. *Photo by Chrys Rynearson.*

Above: The three-story Southend Brewery and Smokehouse is quite eye-catching for passersby, seen here from across East Bay Street. *Photo by Chrys Rynearson.*

Right: Brewmaster Ahren Warf at Southend Brewery and Smokehouse is pictured here in thoughtful discussion with the author. *Photo by Chrys Rynearson.*

A T-shirt adorned with its logo on a surfboard design hangs for sale at COAST Brewing Company. *Photo by Chrys Rynearson.*

A roll of labels for twenty-two-ounce bottles (or "bombers") of COAST's HopArt IPA sits atop a box of empties. *Photo by Chrys Rynearson.*

The husband-and-wife COAST Brewing Company team of Jaime Tenny and David Merritt pose among their tanks, whose contents magically appeared in their glasses. *Photo by Chrys Rynearson.*

Used bourbon barrels sit filled with an aging barleywine at COAST Brewing Company. *Photo by Chrys Rynearson.*

COAST growlers are filled from a small bank of taps that run through the wall of their cold room. Note the handcrafted wooden tap handles. *Photo by Chrys Rynearson.*

A crew of tourers and tasters pose outside COAST Brewing Company, brought together against all odds by local craft beer. *Photo by Chrys Rynearson.*

Left: Custom Charleston Beer Exchange coasters sit atop one of its many shelves of beer glassware. *Photo by Chrys Rynearson.*

Below: A picture of the front half of Charleston Beer Exchange, taken from the growler station. This half of the store is dedicated to American craft beer, while imports line a hallway of shelves to the right. *Photo by Chrys Rynearson.*

Left: Scott Shor (left) and Rich Carley cradle a pair of growlers inside the Charleston Beer Exchange. *Photo by Chrys Rynearson.*

Below: Growler fight! Don't try this at home, and especially not inside the store. These men are trained professionals. *Photo by Chrys Rynearson.*

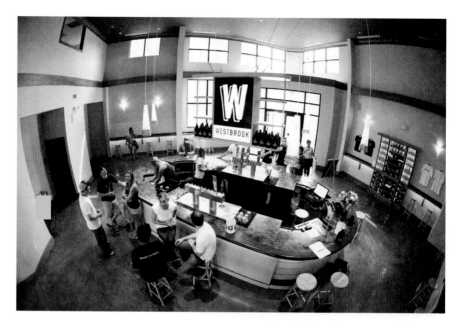

An overhead view of the Westbrook Brewing taproom, taken from the rear facing the front door. Behind this is the humongous brewery floor. *Photo by Chrys Rynearson.*

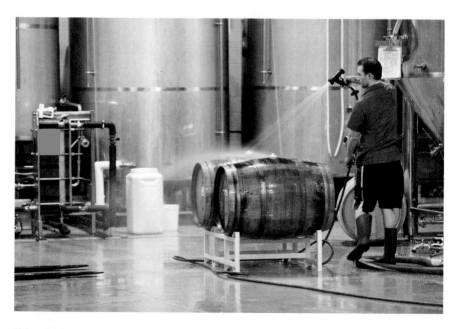

Edward Westbrook washes off some barrels after filling them with beer for aging. *Photo by Chrys Rynearson.*

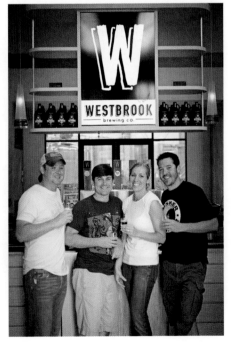

Top: Home brew–sized glass jugs called "carboys" hold five-gallon batches of experimental beers in the Westbrook Brewing barrel room, made bubbly by fermentation. *Photo by Chrys Rynearson.*

Middle: A growler being oh-so-happily filled by the Westbrook Brewing tasting room staff. *Photo by Chrys Rynearson.*

Right: Friends congregate in front of the Westbrook Brewing tasting room bar, enjoying samples and one another's company. *Photo by Chrys Rynearson.*

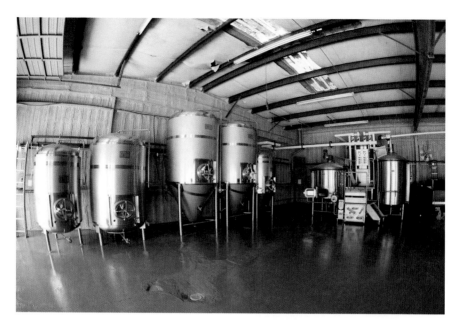

The freshly poured and painted brewing floor at Holy City Brewing in North Charleston. *Photo by Chrys Rynearson.*

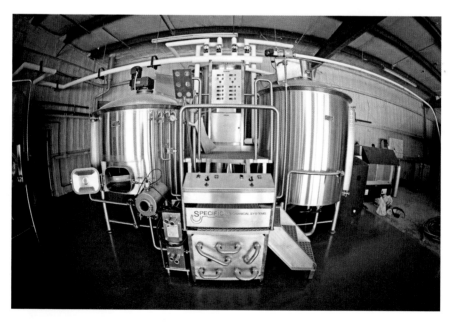

Holy City Brewing's brand-new brew house. The white PVC pipe is part of a grain system built by the owners that will feed freshly milled malt into the kettle by way of an auger. *Photo by Chrys Rynearson.*

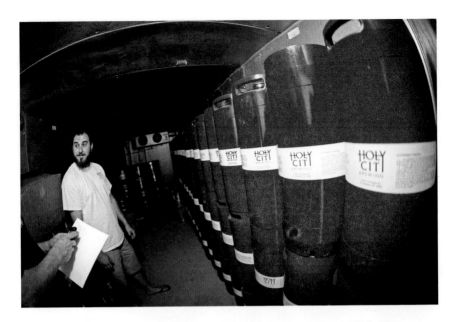

Chris Brown shows off a wall of sixth-barrel kegs inside a container in Holy City Brewing, all covered in a red poly-coat material. The owners pounced on the chance to buy these, seeing it as a way to make their product very recognizable and help ensure their kegs would be returned after use. *Photo by Chrys Rynearson.*

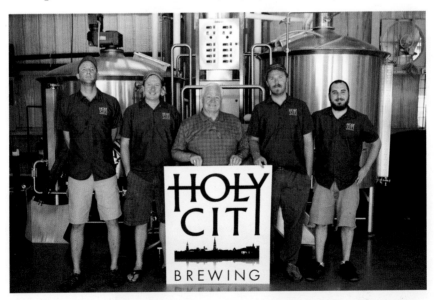

North Charleston mayor Keith Summey stands in the middle of the Holy City Brewing team, welcoming their new business to the city. The team of owners (from left to right) are Mac Minaudo, Joel Carl, Sean Nemitz and Chris Brown. *Photo by Chrys Rynearson.*

Thirsty festival-goers line up at the gates of the first annual Brewvival in February 2010, waiting on the noon opening time. *Photo by Chrys Rynearson.*

The taps at the first annual Brewvival flowed with beers from all over the world, but one could stop by the COAST Brewing table to sample beer made only a few feet away. *Photo by Chrys Rynearson.*

Chapter 6

The Cap Comes Off
(or the Second Boom)

S ince the repeal of Prohibition, South Carolina has had myriad laws related to alcohol, both at the state and local levels. Blue laws still exist in some counties, preventing the sale or service of alcohol on Sunday, for instance. However, one state law had been quietly holding back beer culture in the state for decades. Per our state's definition, beer could not be sold in South Carolina that was higher than 5 percent alcohol by weight (ABW for short, cousin to the more popular measurement of alcohol by volume, or ABV). Wine has a relatively high cap at 20 percent, and liquor has long since been legalized without a restrictive maximum but is regulated separately. A person of age could walk into any given liquor store and purchase a certain brand of 190-proof grain alcohol, but that same person could not walk to his local beer purveyor and purchase a barleywine, imperial stout, double IPA or any other number of exciting beer styles gaining popularity in other parts of the country.

This law was clearly illogical for modern times and was probably written as such to define the difference in beer and wine rather than to prohibit big beer styles. But as laws go, even changing illogical ones can prove quite the challenge. And challenge or no challenge, it takes someone stepping up to the plate and bringing attention to the law to get any movement whatsoever.

BOY MEETS GIRL

Jaime Tenny moved to Charleston with her father during her senior year of high school, having been born and raised in Point Pleasant, New Jersey. It was here that she met David Merritt, a local to whom she paid little attention at first. While they parted ways slightly for college, Jaime attending College of Charleston and David attending Trident Technical College, they began dating during those post–high school years. As they say, the rest is history.

David had taken a keen interest in home brewing by the time he started college. His first brew was Bombay IPA, a recipe from renowned master home brewer Charlie Papazian. This remained a favorite style that would follow him into the future, as you'll soon learn. Determined to turn his hobby into a career and willing to make a serious change of venue, David moved to California at the tender age of twenty to attend brewing school with the American Brewers' Guild. The ABG was and still is run by Steve Parkes, who would later go on to take over Otter Creek Brewing and move the main location of the school to Salisbury, Vermont. While geographically close together, the American Brewers' Guild school is a

Jaime Tenny, co-owner of COAST Brewing Company, poses in a corridor formed by fermenters and brite tanks. *Photo by Chrys Rynearson.*

David Merritt, co-owner of COAST Brewing Company, enjoys the liquid fruit of his labor at the brewery. *Photo by Chrys Rynearson.*

separate operation from the also well-known brewing program run by the University of California–Davis.

Upon his return, David almost immediately began working at Southend Brewery and Smokehouse, with its impressive three-story brewpub and restaurant located on East Bay Street. After brewing there for a year, it was on to Palmetto Brewing Company, where he would work full time for the next nine years. Despite his tenure, he gave no illusions as to what his ultimate plans were. On his first day there, David told the Palmetto crew that he would open his own brewery one day.

Jaime's first exposure to the world of craft beer was largely through David, trying his home brews (which he rarely liked, thanks to his perfectionism) and other beers they would pick up while traveling. It was eventually a brand-

name imperial IPA that would give Jaime the craft beer bug, bringing her fully on board with her husband's hobby-turned-profession. While David gained experience brewing in Charleston, Jaime was hard at work raising their children and working in a number of varied fields. From health food store manager, to yoga instructor, to immunologist, to biodiesel pioneer—not necessarily in that order—she tried her hand at them all.

Throughout these years, the dynamic duo visited and revisited the idea of opening a craft brewery in Charleston. There would always be obstacles to getting it off the ground, from financing, to the time constraints of raising a family, to the then scant enthusiasm for craft beer in the area. It became apparent that one obstacle had to be overcome for the plan to make sense. Removing the years-old, arbitrary cap on alcohol content in beer simply had to happen. When the pair decided to take on the challenge in order to realize their dream, it was also decided that Jaime would be the one to lead the charge. After all, she's from New Jersey.

Fighting the Good Fight

In 2005, Jaime organized Pop the Cap South Carolina from the ground up to accomplish their goal. The name, a play on opening a beer bottle as well as increasing the ABW "cap" on the books, was one used in similar movements from other states. North Carolina's Pop the Cap movement succeeded in the same year that South Carolina's movement started, moving its limit from 6 percent ABV to 15 percent.

Since North Carolina's movement was finished, its Internet domain name was up for grabs. Someone was in line to purchase it, but the deal fell through, so Jaime swooped in to grab it. She admits she was initially headstrong and naïve, having had no experience in and no contacts for moving the state's legislature on an issue that was very low on the radar. The North Carolina team spent many pro bono hours educating her on their challenges, how they eventually succeeded and the patience it would take to get the job done.

The official membership of Pop the Cap SC was made up of the five breweries that were operating in the state at the time. While they are all still open today, none was operating with extra resources that it could dedicate to operating the group. With anywhere from one to three employees, their time was swallowed up just in brewing, so Jaime took the bulk of the work on herself. She made calls, wrote letters and spent time in Columbia attending

meeting after meeting. In that first year, her efforts were largely ignored. It became abundantly clear that Pop the Cap needed a champion that wielded a slightly bigger stick.

Enter state House Representative Bill Herbkersman, representing Beaufort County. Members of his family had opened Columbia Brewing Company, the state's first post-Prohibition brewpub. Their flagship beer was called Cock Red in honor of USC's mascot. Mutual friends recognized the connection and referred them to each other. While Representative Herbkersman was supportive of the cause on principle alone, he took the issue on as one concerning free enterprise and the support of small businesses. He introduced the first Pop the Cap bill in 2006, but his position proved to be in the minority, as the bill failed miserably. Some derided it publicly for the same tired reasons of "moral responsibility" and "protecting the children," but more was at work than met the eye.

It was during 2006 that the movement both fully recognized and began working with one of the bill's biggest initial opponents: the state's beer wholesalers. With a powerful lobby representing long-established, large businesses, Pop the Cap would need wholesaler support to move forward. One can hardly blame the wholesalers, having prospered for years distributing mainly big-brand American light lagers. The concept of craft beer, the craft beer consumer base and the profit potential there was entirely foreign to them at the time. Because of this, Pop the Cap took the tack of education with the wholesalers. The group met with them many times, explaining the business model and the win-win results that would come from the bill's passage. Finally, consensus and compromise were reached, and the wholesalers agreed to drop their opposition.

By that time, beer in North Carolina was thriving. After two years of traction following its legislative victory, all facets of the business were booming. Roughly twenty craft breweries were churning out quality products, and towns like Asheville were becoming beer destinations. A few short years later, Asheville would be dubbed "Beer City USA" in both 2009 and 2010 in a national online poll. On top of purely local interest and consumption, beer tourism started to take hold. This was a relatively new phenomenon in the Southeast, but North Carolina was starting to see it take off. Like any other form of economic growth, all this was leading to quantifiable results, namely jobs and tax revenue.

Pop the Cap was also mounting serious grass-roots support for its cause. An estimated four thousand South Carolinians contacted the legislature in support of the new bill Representative Herbkersman introduced in the 2007

legislative session. Lo and behold, on May 2, 2007, House Bill 3218 was passed. The state's alcohol cap on beer was officially popped from a puny 5 percent alcohol-by-weight to a respectable 14 percent. In ABV terms, this meant a move from 6.25 percent to 17.5 percent. The organization, now renamed the South Carolina Brewers Association, and beer enthusiasts throughout the state never looked back.

The COAST with the Most

In the midst of trying to change the state's beer laws for good, Jaime and David's brewery planning was going full steam. An early idea was to use a logo including a capital "C" whose upper half was a cresting wave, a surfing reference. Breweries generally have two options when it comes to names: something totally unique to make you stand out or something more general that is accessible but can also confuse you with other breweries. The duo scoured the dictionary for a word starting with "C," but the only one that seemed to fit their style, ideals and location was "coast." Other breweries

The seven-barrel brew house at COAST Brewing Company is a relatively small affair but consistently churns out craft beer of the highest quality. *Photo by Chrys Rynearson.*

Spent (used) grain at COAST Brewing Company is placed in these buckets for easy access. Local farmers, in turn, use this grain to feed their livestock, closing the sustainability loop that begins at faraway barley farms. *Photo by Chrys Rynearson.*

have the word "coast" as part of their name, but none used it as the whole name, and certainly none capitalized the entire word. And thus, the name "COAST Brewing" was born.

Opening a brewery in South Carolina in the mid-2000s could have been considered a bad idea. In fact, it was. Our beer culture was not yet thriving, our beer laws were still fairly oppressive and the combination of these things did not produce a huge desire from banks to loan money to would-be brewers. The idea was so seemingly bad that even Jaime's and David's friends and family cautioned them against the move, going so far as to dare them to do it. The assumption was that they would fail quickly, cut their losses, learn their lesson and prove conventional wisdom right. While the stakes were high and the deck was stacked against them, the couple was not deterred. One might even say they were driven by the opposition. The brewery would be opened, even if it was a bad idea.

Location scouting did not go particularly well. When they couldn't find anything that seemed right, Jaime mentioned their dilemma to the property manager at the Navy Yard at Noisette, where she was working in biodiesel at the time. He took them to a building that had previously housed documents for the navy when the base was still operating. They

walked up the loading dock, peered at the field across the street and immediately envisioned a beer festival there. With spirits high, they went inside to survey the layout and decided it was just what they were after. They remain in that building to this day.

With a location secured, a small, seven-barrel brewing system was procured, along with some fourteen-barrel fermenters. A biodiesel system was put in place to heat the system, part of their personal ideals and professional commitment to sustainability. They also committed to use organic ingredients whenever possible and provide their spent grain to farmers for animal feed, fulfilling their motto: "local, creative, organic." A flurry of paperwork, permits and other preparations were next, things any new small business must go through made more complicated by their line of work. If that wasn't enough, when they flipped on the electrical system for the first time, all they got was a loud "click." As the building was on the navy base, it had previously run on navy power and was never hooked into the city's electrical grid. That unforeseen setback pushed their opening date back two months, but after cooperation from the Noisette group, they were finally online. COAST Brewing officially opened in March 2007, two months before Pop the Cap passed.

This Little Brewery Went to Market

One of the main reasons for opening the brewery was to bring the full expression of David's brewing to fruition. This came with a desire for stylistic freedom and an avoidance of playing it safe. COAST would either thrive or die on the proverbial vine, but regardless, they were committed to being true to themselves. With such lofty ideals, a relationship with an established distributor would have been a challenge. Given the state's three-tier system, there was no choice in the matter. A distributor would have to be part of the picture.

In walked Les Addis. The Camden, South Carolina native got his start home brewing toward the end of his stint at college after being turned onto some English imports that opened his mind to the art of beer. He spent time in Oregon working for Mount Hood Brewing before returning to Charleston to work with Palmetto. It was there in the late 1990s that Les and David became acquainted as the youngest two in the handful of folks working in craft beer in the city.

The Cap Comes Off (or the Second Boom)

Fast-forward to 2007, and we find Les taking it upon himself, given some planning with the COAST crew, to create a one-man distributorship solely to handle their account. This would allow COAST the freedom it desired, an easy distributor relationship given their past exploits together and a chance for customers to experience the same home-grown, hands-on approach they brought to brewing. Les's company, dubbed Gravity Distributors, would sell the first keg from COAST, full of HopArt IPA, to nearby EVO Pizza in Park Circle. After roughly two years spent bringing COAST's wares to market in his SUV, Les ended his distributorship to focus more on his family, leaving COAST in the capable hands of an established outfit whose ranks he joined as well.

Of course, that wasn't the last obstacle the COAST crew would face. They still had to raise two children, and both continued to hold down full-time jobs to do so, as did Les with the distributorship. They would continue that hectic schedule for eighteen months after they opened. However, it was a labor of love, and they believe in their product. Speaking of product, let's get to the fun part.

The Beers of COAST

With the shackles off, it was time for the COAST crew to get down to business. There was no pilot system in the brewery, so any batches made there would be made on the full-bore seven-barrel system. David had over a decade of home-brewing experience under his belt, so one would think he had spent that time perfecting recipes for his dream brewery. Whether he did or not, his home brew recipes went out of the window. None of COAST's beers were recipes from his home brew days. One of the initial year-rounds was an esoteric style he'd never even brewed before. This was a very risky venture but very much in the spirit of COAST.

They decided to always crank out two year-round beers, both of which are still made today. One makes up half of all the beers in the history of the brewery that could have legally existed prior to popping the cap: 32/50 Kölsch, weighing in at 4.8 percent ABV. The Kölsch style was born long ago in the city of Cologne, Germany—the name of COAST's version is a reference to the approximate latitude of Cologne (50) versus the latitude of Charleston (32). It has the appearance of a lager but with a more crisp character and balanced hop bite. It quickly becomes

apparent why this was selected as a year-round. The style is great for warm weather thanks to its lighter character, but it remains unique and flavorful enough to differentiate itself from the regular lineup of warm-weather offerings.

Year-round offering number two is HopArt IPA, perhaps what the brewery is best known for. This is a 7.7 percent ABV American India Pale Ale packed with an ever-tweaked combination of hops, amber-hued and simply delicious. The IPA style is a modern derivation of beers that used to make the trek from England to India in the days of the British Empire. While hops have a fantastic and unique flavor profile, they also serve some important functions in beer. Mainly, they act as a natural preservative and antibiotic, staving off staleness and taste-crushing organisms that can creep in, especially in those days. A strong, hoppy beer was a sailor's best friend if he needed beer throughout his journey.

American craft brewers have especially taken to the style, pushing it to the edge of both alcohol and hop content. The double IPA or imperial IPA label eventually started being applied to some brews that were so over the top it was unfair to compare them with the rest of the American IPAs. Some breweries now label a few select recipes as Triple IPAs, and then there's India brown ale and the contentiously named India black ale. The point is, American craft beer drinkers love bold flavors by and large, and the sometimes bitter, sometimes grassy, sometimes citrusy, almost always delicious IPA style was a natural fit.

The monstrous, dark, roasty concoction known as Blackbeerd Russian Imperial Stout is probably COAST's second most well-known offering. At 9.3 percent ABV, this annually released opaque stout is not for the faint of heart. The style is another one born of voyage, this time from England to the imperial courts of Russia. These beers were efforts in diplomacy, an attempt to impress and delight Russian nobility made by the English. To survive not only the long journey but the bitter cold as well, the beer was packed with hops and even more packed with roasted malts. The slightly smoky, coffee-like character of the malt is delightful, but mainly they were heaped in to increase the fermentable sugars in the brew and, therefore, the alcohol content of the finished product.

It seems every American craft brewery striving for greatness today needs a Russian imperial stout. Its relatively extreme character has made this another style ripe for being co-opted by our brewers. By their nature, they are expensive to make due to the sheer amount of ingredients involved, so most have opted to make them an annual release, as COAST has. If beer

rating websites tell you anything, it's that COAST's version of the style holds its own with the most well known.

The rest of the brewery's portfolio is made up of seasonals, some recurring and some not. Its first foray in this realm was Rye Knot Brown Ale, a great autumn beer that combines hearty rye malt with chocolate malt for a slightly sweet, deep drinking experience that doesn't quite tip the tipsy scales at 6.2 percent ABV. This remains one of six beers from COAST to make it into twenty-two-ounce bottles, along with the aforementioned three, Old Nuptial Bourbon Barrel-Aged Barleywine and Boy King Double IPA. Other seasonals have included Carnie Fire Hoppy Red Ale, Red Legs Scotch Ale, the Belafonte (a Belgian pale) and the list goes on with over twenty in total. COAST is now regularly producing two seasonals at a time, thanks to some recent equipment upgrades. While the list of what they want to brew always outpaces what they can, one cardinal rule presides over the pair's seasonal selection process: it's what they want to drink.

It's hard to say what is next for Jaime, David and COAST. Their beer is in high demand and held in high regard wherever it's available. While expansion remains an option, it's not a certainty. If their short history proves true, what does remain certain is that they will stay true to themselves and put the beer first in everything that gets the COAST stamp.

Chapter 7

The Return of the Growler

The passage of Pop the Cap legislation in South Carolina not only marked the beginning of exciting new opportunities in brewing but, more immediately, also opened the floodgates for craft beer retail. Opening new brewing operations, or expanding existing ones, comes with the risky expense of opening or expanding any small business. Investment in heavy equipment and licensing requirements are just two of the many barriers to entry. This is not to mention the time and effort spent planning, brewing and tasting test batches to perfect new recipes before bringing them to market. God help those poor beer tasters.

Unlike breweries, retail establishments could reap the benefits of the new law on day one. All they needed was a little shelf space and a sense of adventure. Even before beer distributors expanded their offerings with additional breweries, those already available in South Carolina could now sell their stronger selections here. As dedicated shelf space grew and previously uninterested retailers saw dollar signs, Charleston's beer horizons were ever broadened. Little did they know that a tiny shop downtown was about to become a big fish in our malty pond.

Two Guys, a Girl and One Guy's Mom

Scott Shor and Rich Carley met while attending Northeastern University in Boston, both having come from different parts of New York state. Scott

Scott Shor (left) and Rich Carley pose proudly under the signage of their store, the Charleston Beer Exchange, located at 14 Exchange Street downtown. *Photo by Chrys Rynearson.*

spent a number of years managing a high-end beer, wine and spirit store during and after leaving college. It was during his stint there that a love of great wine and liquors morphed to include a serious devotion to beer. Rich also caught the bug, and the two began doing all the things beer geeks do: traveling, trading and learning all the minutiae that come with the territory.

The two shared an apartment at the time, along with Scott's then-girlfriend (now wife) and their dogs. It was Scott's future wife, Tracey, who led the trio to move to Charleston to be a little closer to her family, who had recently relocated here. Rich soon shipped off back to New York to pursue some opportunities in real estate, while Scott and Tracey stayed in the Lowcountry.

A gig cooking at Ted's Butcherblock reignited an interest in retail for Scott, as owner Ted Dombrowski put him in charge of their small but serious craft beer selection when he discovered Scott's wealth of knowledge. In Scott's time there from 2007 to early 2008, Ted's became a central point for local beer culture. The first bottles of COAST beer were sold from there, the first COAST beer dinner was held there and just as Scott was leaving, they started what has become the longest-running regular beer dinner series in the city. That partnership has continued, as Scott hosts beer dinners with Ted whenever possible. While all this signaled the city's beer culture moving forward, the fact that Charleston's beer nerve center was a butcher shop is indicative of how far we had to go and, in retrospect, how far we've come.

It was becoming clear to Scott that the city was ready for a 100 percent beer-focused business. COAST had been open for nearly a year when he left Ted's, and they encouraged him to go for it. He called on Rich to return, and planning began in earnest. The pair considered opening a bar, but with no experience in that field between them, they settled on the more familiar territory of retail. They found a small but ample storefront on Exchange Street downtown, just behind the Old Exchange and Provost Dungeon, and pounced on it. Rich's mom thought Charleston Beer Exchange had a nice ring to it, and the guys agreed. They were poised to open a no-frills bottle shop when the idea of selling growlers started floating around.

A Brief History of Growlers

In the pre-Prohibition days of the late nineteenth and early twentieth centuries referred to in previous chapters, households relied on local breweries or taverns for their in-house beer supply. A lack of efficient home

refrigeration meant regular trips to said establishments to get a growler filled. "Rushing the growler" was a common phrase back then, as children generally did the dirty work of retrieving and delivering growlers for parents or work crews, be it midday or evening. While this might seem like innocent nostalgia, the sight of children running buckets of beer around major cities was used by Prohibitionists as an example of alcohol's devilish corruption affecting even the youngest of citizens. The practice was labeled "bucket trade" and was lumped in with selling alcohol to the underage and on the Sabbath as another symptom of its pervasive evil.

Specific accounts of the phenomenon were recorded on both coasts. Jacob Riis, author of *How the Other Half Lives*, opined in 1889 that he doubted "if one child in a thousand, who brings his growler to be filled at the average New York bar, is sent away empty handed." A little later, in 1902, a teacher named Lucy Adams was shocked by the social mores of Portland, Oregon, noting that she "saw men and women and even children emerging onto the sidewalk carrying pails of beer to take to their homes."

Despite what was a national craze, there is little mention of growlers in the annals of beer history in South Carolina. This is likely due to the dispensary system taking hold before the popular custom made its way to the state. The very idea that one could get an unregulated container filled with an unregulated amount of beer certainly would have contradicted the rigid ideology of Ben Tillman. With Prohibition beginning so soon after the dispensary ended, growlers never stood a chance.

Originally, a growler was simply a lidded pail made of galvanized metal, supposedly named because of the noise made by the beer's carbon dioxide escaping through the lid on the trip home. Folks were known to coat the interiors of their growlers with lard. While there's little chance this improved the taste, it prevented much of a head from forming, requiring more beer to fill the bucket and therefore stretching the consumer's dollar a bit. Growlers later evolved to include some wax-lined cardboard containers and, eventually, plastic.

Modern growlers have been upgraded to a variety of shapes and sizes, but most commonly they are sixty-four-ounce glass jugs with screw-top lids. The reintroduction of the growler in this form is generally attributed to Wyoming's Otto Brothers' Brewing Company (now Idaho's Grand Teton Brewing Company) in the late 1980s. Despite design improvements, their basic function is the same. They are vessels providing the means to consume fresh draft beer at home.

Ideas Coming to Brew-ition

Selling growlers at breweries and brewpubs has been common practice for some time, and there are retail locations selling growlers throughout the country. In South Carolina, however, they were basically unheard of. There had been instances of growlers being sold in the state, one being a store in Columbia selling them as part of the launch of COAST Brewing. However, no permanent "growler station" was set up, and the practice was far from frequent.

One reason may have been the mystery surrounding their legality in the state's law books. In fact, there is no mention of them in the state's laws at all. While North Carolina's laws allow for the sale of pre-filled growlers in retail stores, filling them in-store for sale is prohibited. Since South Carolina's laws do not address the practice, one would have to assume that it is legal by default. Columbia's growler experiment proved successful, and some growlers were even sold in Charleston at Ted's Butcherblock in conjunction with a COAST dinner while Scott was still working there.

The close relationship with the COAST Brewing crew was part of the reason Charleston Beer Exchange ended up having the state's first growler station. Selling their brews was already part of the CBX business plan, and when they got started, all of their beer was available in draft form only. There was also the eco-friendly aspect of growlers, since they are reusable basically forever, and of course the pure novelty of offering them in an area that was largely unaware of their existence. This combination of factors led to Scott and Rich installing a custom cooler, six draft lines, a sink and everything else necessary to bring a high-quality growler experience to life.

On November 15, 2008, Charleston Beer Exchange had its soft opening. The store was well stocked with bottles, five beers were on tap and they had one hundred empty growlers emblazoned with their logo ready to fill and sell. Part of that first day was spent working out kinks, as they had gained nearly all of their growler knowledge from their buddies with COAST, but things went off largely without a hitch. All one hundred growlers were sold in two weeks. With a two-week lead time in ordering more, they scrambled to fill the demand, but the cat was out of the bag at that point. Charleston had growler fever, and CBX had more proverbial cowbell.

Through word of mouth and social media, the store started spreading the word about events centered on the growler station. They have actually never paid for a dime of advertising since opening their doors. Regular happenings like "Rare Beer Tuesday," in which a hard-to-find beer

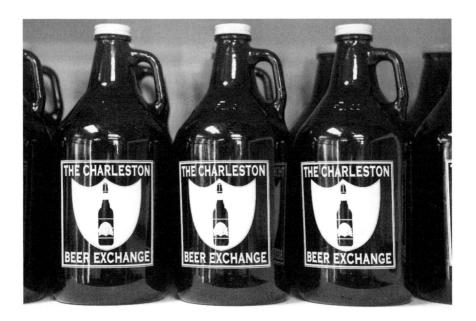

Custom-printed sixty-four-ounce brown glass growlers on the shelves of the Charleston Beer Exchange eagerly await being filled for a thirsty customer. *Photo by Chrys Rynearson.*

is put on tap for growler fills, became a central part of any Charleston beer lover's schedule. The growler station expanded to include nine taps. Brewers occasionally visit to promote their wares, talk to customers and sign various and sundry swag. The store was working not only to provide a premium retail option but to create awareness of new and exciting beer in the booming world of craft brewing.

Fast-forward to 2011, and craft beer culture in Charleston, and in South Carolina, is unrecognizable from only three years prior, when CBX opened its doors. Brands that were unknown back then are now highly sought after by newly learned beer enthusiasts. Oddball, draft-only beer is now regularly available for home consumption. There are now no fewer than nine other establishments currently offering growler fills in the Charleston area alone, with no fewer than ten others elsewhere in the state and more certainly in the works. Arguably, the state and local culture is so young with so much room for growth that, for now, more is simply better. However, not all growlers are created equal.

The Finer Points of Growler Filling

Wherever there's a new trend that results in exponential growth, there's room for variation. But there's also room for cutting corners as businesses scramble to take advantage of a potential cash cow. Selling growlers is no exception. Consider this brief section my effort at unbiased consumer advocacy. A public service, if you will.

Draft beer is fragile once it leaves the tap. Think about it. The package is designed to get beer into a glass and then directly into your belly, with a short pit stop on your taste buds to bring you a little joy. So the notion of repackaging it for consumption hours or even days later is not one to take lightly. If you respect the beer you're pouring, then care needs to be taken to ensure the best possible drinking experience.

Step one in ensuring your growler of beer will be delicious is having a clean growler. Given the choice, I think we'd all agree that a clean glass full of beer would be tastier than, say, a moldy glass full of beer. Given that growlers hold beer for longer than your glass ever would, are designed to

The nine-tap growler station at the Charleston Beer Exchange stands ready to dispense craft beer. Sanitized tubes are already attached to the taps so that growlers can quickly be filled in the proper, bottom-filling fashion. *Photo by Chrys Rynearson.*

be reused over and over and are hard to clean and dry due to their shape, this can pose a serious problem. The best growler stations make this a non-issue by sanitizing any growlers before filling them. This involves soaking the growler in a diluted, food-grade solution to kill any stray bugs or mold that might be lurking inside. While no organism physically harmful to humans can grow in beer, plenty of organisms that affect taste can.

Once your growler is clean, it's time to look toward the tap. Simply pouring the beer into the mouth of the bottle is not desirable. The splash of the beer hitting the bottle allows lots of carbon dioxide to escape and exposes much of the liquid to oxygen before the growler is capped. The result is flat and stale beer, which is perhaps the only thing sadder than no beer at all. Instead, a vinyl or plastic (hopefully food-grade, and hopefully sanitized) tube is attached to the tap. The tube is then inserted into the growler until it comes close to the bottom, and beer is poured through the tube. This "bottom filling" method results in minimal oxidization and carbonation loss, as most of the beer is being poured directly into more beer at the bottom of the bottle.

Finally, the growler needs to be capped tightly while the beer is still foaming out of the top. Filling the growler and leaving a little space at the

Scott Shor has become so adept at capping growlers at the Charleston Beer Exchange that he can do it one-handed while looking at the camera. *Photo by Chrys Rynearson.*

Having filled, capped and rinsed the CBX growler, Scott Shor happily dries it off with a quickness. *Photo by Chrys Rynearson.*

top, or even filling it to the brim, will result in a little pocket of air at the top. This is bad news, as that air will work against the flavor, oxidizing the beer. A growler capped while foaming will also result in a little empty space once the foam dies down, but the space will be occupied by carbon dioxide. Tightly capped, this will not hurt the beer one bit.

An establishment following these guidelines will ensure your growler is full of beer that will still be delicious once you get home. A properly filled and sealed growler could potentially last for weeks after being filled—whether the style is appropriate to drink in that non-fresh state is another question altogether. Of course, there are still other options to explore. Brown glass growlers will better protect the beer from light, which causes the condition commonly known as "skunking," just as brown glass bottles do. Some joints will even seal the outside of the cap with a little plastic ring made tight with a heat gun.

After nearly three years in operation, Charleston Beer Exchange has earned a reputation among beer enthusiasts as one of the best retail locations in the Southeast and certainly as a pioneer in South Carolina. Even more, in

2011, it was officially ranked the number two beer retailer on the planet, and first in the United States, by Ratebeer, a worldwide resource for beer ratings and discussion. It now offers nearly one thousand different bottles on any given day, ranging from beers brewed locally to imports from Japan, Italy, Belgium, New Zealand and elsewhere. Business is clearly booming, as the Greenville Beer Exchange opened its doors in the upstate on New Year's Eve in 2010.

Chapter 8

The Thirst Continues

Brewery Tours, Direct Sales and Tastings

Talking about craft beer in the state of South Carolina is inextricably linked to legislation. As we struggle to bring our state in line with others more advanced in this area, each step forward tends to be a long slog. That was certainly true with Pop the Cap legislation, and it was also true with the next law that Jaime Tenny and the South Carolina Brewers Association would tackle.

In our state, beer had to be sold through a distributor before reaching a consumer. The traditional "three-tier" system was set up after Prohibition ended in an effort to tightly control what alcohol got where, when and to whom. It also worked to ensure space in the market for alcohol distributors as long as there is a demand for alcohol. A perhaps unintended consequence of the system is that breweries in South Carolina could not sell any products directly to their customers. Brewpubs were made legal some time after this, but they are legally held to only producing two thousand barrels of beer per year, cannot sell outside of their premises and cannot participate in functions like beer festivals since they are not officially distributed in the state. So while in other states one could visit a brewery, have some samples, maybe have a pint and leave with some beer to take home, we could do none of this in South Carolina. Likewise, a small, struggling brewery was forced to basically give up a chunk of profit margin on every sale to a distributor, whereas it

could get additional profit and quick cash flow from some direct sales to consumers. This put our state's breweries at a distinct disadvantage to even neighboring states, stunting our growth in the industry and encouraging beer entrepreneurs to set up shop outside of our borders.

In a related issue, beer tastings in retail establishments in the state were illegal. While wine tastings had long since been legal, and recent legislation allowed for liquor tastings (in support of "micro-distilleries"), beer was left behind. Of all the laws one encounters when dealing with this subject, this one was a real head-scratcher. When every form of alcohol tasting is legal except for the one with the lowest alcohol content, there are clearly flaws in your alcohol laws.

SCBA to the rescue! In 2009, Jaime was still president of the association, and it once again enlisted the help of Representative Herbkersman to introduce a bill rectifying the brewery sales issue in the 2009 legislative session. House Bill 3693, unfortunately, did not see the light of day. Once again, opposition came chiefly from the state's beer wholesalers. This time, the bill hit a little too close to home—no longer are we talking about an unknown product entering their marketplace but, rather, the potential for direct competition and a threat to their guaranteed position as a go-between from producer to customer. Once again, one can hardly blame them.

Between the 2009 and 2010 legislative sessions, the brewers worked closely with the wholesalers to negotiate a compromise. Beer tourism, tax dollars and the growth of the craft segment as a whole were once again referenced as reasons for supporting the bill. Given that the ice had been broken during the negotiations around Pop the Cap, the brewers and the wholesalers were able to reach a compromise that summer. From a sample standpoint, they landed on four 4-ounce samples per person per day (2 ounces for beer with higher alcohol content), in conjunction with a brewery tour. Direct sales were likewise limited to 288 ounces per person per day, the equivalent of four 64-ounce growlers, twelve 22-ounce bombers or twenty-four 12-ounce bottles. The language in the bill was updated, and it was reintroduced in the 2010 session.

During the same session, House Bill 4572 was introduced, potentially allowing beer tastings to occur in retail locations, given some restrictions. During the session, the language from 3693 was tacked onto 4572, making it the ultimate beer bill of 2010. Its passage would be the best possible outcome South Carolina beer lovers could hope for that year. After some dramatic stall-outs, cancelled meetings and lots of consumer support, the bill made it through.

You, too, can now experience the joy this man feels by personally purchasing local beer directly from the hands of its producers, thanks to the recent legislative victory of the South Carolina Brewers Association. *Photo by Chrys Rynearson.*

Today, you can visit a local brewery during tour hours and have some samples or take some beer to go. To think that only two years ago that was not an option is almost unthinkable. While the next step in improving the state's legal position on craft brewers and retailers is yet unknown, one would hope we can say the same thing in the next two years.

BREWVIVAL

What thriving beer scene is complete without a killer beer festival? Thanks to the collaborative efforts of Charleston Beer Exchange and COAST Brewing, Charleston is now the annual home of Brewvival, a young beer fest with an already serious reputation among devotees.

The inspiration for Brewvival started with the location. When COAST Brewing cranked up at its still current location at the Navy Yard in Noisette,

A poster from the first Brewvival in February 2010, listing the brewers represented and other special guests, is laid over a barrel. *Photo by Chrys Rynearson.*

Jaime and David surveyed the field across the street and knew it was the perfect site for a beer festival. That was in early 2007. Fast-forward to February 2010, and the first annual Brewvival opened its gates to over one thousand thirsty beer lovers ready to delve into some of the finest creations in the craft beer universe.

Brewvival's big selling point, and what has put it on the map with beer geeks, is its selection. Generally, beer festivals have a selection running the gamut from the unremarkable to the remarkable. Entry is largely unrestricted to whatever a brewery or distributor chooses to bring out. This is because, again generally, the beer at a beer festival is not purchased by the organizers. Relying on donated beer from breweries and distributors really leaves an organizer with no room to choose what shows up. For most beer festivals, this model works just fine, and there's nothing intrinsically wrong with it. It allows organizers to maximize their profits (within reason), gives brewers and distributors a chance to showcase whatever they like in an effort to increase awareness and eventually boost sales for those brands and results in a beer selection that can cater to casual beer drinker and beer enthusiast alike.

The folks at COAST and CBX never planned to organize a "regular" beer festival. They planned to organize the beer festival they would want to

attend. Because of this, they opted to purchase all the beer for the festival outright. This meant they could choose exactly what brews would be there, ensuring the presence of barrel-aged beers, wild ales, rarities and, most importantly, nothing run-of-the-mill. In some cases, this included beers never before available in Charleston, South Carolina or even the Southeast.

This attention to detail of course comes with added risk. Adding beer to the list of expenses means that ticket sales have to be there in order for the festival to come out on top. Judging by the fact that a second annual Brewvival happened, we can rest assured the risk paid off. There is also inherent benefit to this festival model, not least of which is that breweries are very willing to send out representatives to talk about the beer and share information with the attendees. In some cases, even brewery presidents and brewmasters showed up to the first annual event, including Greg Koch from Stone Brewing in Escondido, California (also the keynote speaker), Patrick Rue from the Bruery in Placentia, California, and Oscar Wong from Highland Brewing in Asheville, North Carolina.

Beyond just beer, the festival also provides a chance for handpicked, local eateries and caterers to showcase a few selections. Bands play on a stage at the far end of the festival grounds throughout the fest's 12:00 to 6:00 p.m. time slot. Add in a T-shirt table and, in the second year, a table for Low Country Libations to share information and sign up new members, and you have all the makings of a beer-centric afternoon with friends you've never met before.

That group of new friends expanded for the second edition of Brewvival in 2011, with an estimated 1,800 folks in attendance. The sellout crowd had its way with about one hundred beers from about thirty breweries, with nary a frown in sight. It will be exciting to watch how the festival may change in 2012, assuming that we get a third annual version, but word is certainly out that Brewvival is the place to be for beer lovers on the last Saturday in February.

WESTBROOK BREWING

An eastbound jaunt down Interstate 526 will take you right by a new Lowcountry brewing landmark, Westbrook Brewing. The two-story, purpose-built facility in Mount Pleasant cost an estimated $2.2 million and measures about eighteen thousand square feet. It features, among other

things, a huge brewing floor that can yield four to five thousand barrels per year (with room for up to twenty thousand if filled to capacity with fermenters), a barrel room for aging brews in a variety of fresh and used wooden barrels and even a tasting room with an oval bar surrounding twenty taps. Westbrook officially launched in late December 2010 with distribution throughout South Carolina, presumably with other states looming on the horizon.

Like most professional brewing operations, Westbrook was born out of its founder's home brewing hobby-turned-obsession. Edward Westbrook was born and raised in Mount Pleasant, eventually attending Furman University with a major in computer science. It was a sip of Guinness in Spain, of all places, that first exposed Edward to the world of non-macro beer. A year later, a vacation to the UK really opened his eyes and palate to the variety of experiences that beer can provide, especially from the carefully crafted cask ales being poured in London pubs. Maybe more importantly, it dawned on him that he could be making this stuff himself.

He returned as a senior at Furman University; bought home-brewing supplies; tapped already established Upstate brewers at Blue Ridge Brewing Company, RJ Rockers Brewing Company and Thomas Creek Brewery; and never looked back. By the time he graduated, it was becoming clear that computer programming was not his calling. He went on to procure an MBA from Clemson University while brewing roughly once a week. As soon as his MBA was complete, he began working on a brewery business plan. Eventually, his timing played out well with the passage of the tastings and direct sales law, but the brewery's roof was already installed when it passed, so Westbrook would have gone full steam ahead regardless. Now in his mid-twenties, Edward is living the dream, running his own brewery and establishing his brand as a unique addition to the beer scene in the southeastern United States.

If anything sets Edward apart from other southern brewers besides his age, it's his stylistic focus. Westbrook Brewing specializes in Belgian-style ales, while still delving into some American styles. There are other U.S. breweries in this arena (the Bruery in Placentia, California, and Brewery Ommegang in Cooperstown, New York, just to name two), but none of size is in the South. Carving out this particular niche differentiates Westbrook from other breweries in the region, hopefully finding its place in a market segment dominated by imports and other regions of the United States.

The brewery leads with three year-round selections. White Thai draws inspiration from the traditional wheat beers of Belgium (or *witbier*), with the

Brand spanking new kegs at Westbrook Brewing sport their embossed namesake, logo stickers and a set of black-and-white stripes. *Photo by Chrys Rynearson.*

unique addition of ginger, lemongrass and a recently developed hop varietal from Japan called Sorachi Ace. Belgian Pale Ale is exactly what it sounds like, with the Euro-centric addition of malt from Germany and hops from the UK. Finally, India Pale Ale is the closest to an American style of the flagship brews. While it has the distinctly American gung-ho of quadruple hop additions during the boil and double dry hopping, it still has a bit of German malt for good measure.

These three brews will remain the focus of the brewery as it reaches a sustainable loop of supplying its customers, getting kegs returned and starting the process over again. Everything is draft only for now, but there are plans to install a canning line to can two of those year-round offerings. Westbrook has begun rotating some special releases—a Belgian IPA was an early entrant, with a Belgian tripel on its heels and a Belgian quadrupel soon to follow. Even smaller batches are brewed on occasion, generally yielding only one keg. These provide a proving ground for test batches and will remain available only at the brewery since the batch is so small. Citra Rye Pale Ale was a particularly delectable test batch available at the brewery's grand opening that since became a seasonal.

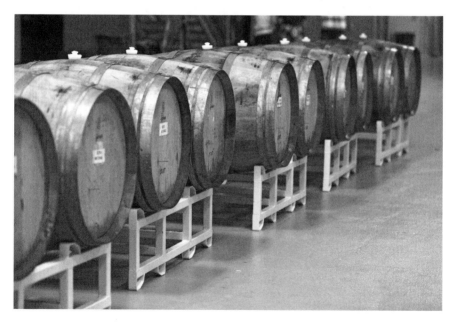

Used wooden barrels are lined up on the floor of Westbrook Brewing, ready to be filled with and age beer from nearby fermenters. *Photo by Chrys Rynearson.*

Edward Westbrook, founder of Westbrook Brewing, pours samples during one of his launch events at Charleston Beer Exchange in December 2010. *Photo by Chrys Rynearson.*

The aforementioned barrel room is yet another space for experimentation. Small amounts of special releases like the tripel and quadrupel will make their way into any number of barrels, perhaps American or French oak barrels used previously to house red wine, changing their character and adding complexity. Some of these barrel-aged beauties will eventually be packaged in 750-milliliter bottles (think of a standard wine bottle) and released sparingly. Given time, sour styles like Flanders Red Ale might also find their way into and out of barrels at Westbrook, while other brews might be aged in barrels that housed whiskey, rye, brandy, bourbon and even cognac if we're lucky. A procurer of barrels is at the mercy of what's available at a given time, but Edward has his eye on some very wild stuff.

Westbrook prides itself not only on its beer but on its sustainable brewing efforts as well. Solar panels are used to heat water for the mash tun and kettle, and a giant fan has been installed to push air around the brewery instead of a costly air conditioning system. The lighting is as green as can be, mainly reliant on huge skylights, and even rainwater is being routed for use in irrigation around the brewery.

While the operation is huge, Edward's calm resolve and tasty beers will hopefully make it a success. His plans are big enough to outmatch his building.

Holy City Brewing

A true team effort, Holy City Brewing is the brainchild of four guys with differing backgrounds who joined forces to bring another local beer choice to market. With industry experience as diverse as biodiesel, rickshaw

The small brewing system sitting atop a set of welded bicycle parts followed the Holy City Brewing team from their old rickshaw garage all the way to the new brewery, where it remains in use as a pilot system. *Photo by Chrys Rynearson.*

operation and, of course, brewing, Holy City's story highlights the ability of beer to bring otherwise unrelated folks together to share ideas and make things happen.

Joel Carl and Sean Nemitz were running a local rickshaw company and started doing a little home brewing in their garage during the off-season. The two originally met during college, with Joel being from Charleston and Sean coming south from Vermont to attend school. Before long, they had cobbled together a fifteen-gallon system made partially of old bicycle parts and were sharing the fruits of their hobby with friends and employees. Joel and Sean were introduced through mutual friends to Chris Brown, a transplant from Atlanta by way of Colorado with some professional brewing experience. They all shared a love of the art of beer making, but plans to go pro had not yet materialized.

In walked Mac Minaudo, another Charlestonian who returned home after living in Asheville for some time running a biodiesel collection/ refining service. Mac planned to continue in the same vein here, just dropping the refining and focusing on collection. He went so far as to acquire a four-thousand-square-foot warehouse off Dorchester Road in

North Charleston. Mac found that the biodiesel business in Charleston left a bit to be desired and decided against continuing to pursue it, but the space on Dorchester remained.

When Mac's company was still in the planning stages, he had planned to offer up a quarter of his warehouse's space to friends Joel, Sean and Chris to start brewing. The trio had some aspirations to become professional but planned to start very small, so a quarter of a warehouse was plenty of room. But when the biodiesel company didn't happen, the foursome decided it was time to go big or go home. The warehouse would become a full-fledged brewery, and all four would pursue their passion together.

A casual coffee house conversation led to the name Holy City Brewing, one the brewers were shocked to find available both as a business and a website. The plan was to create a brewery to serve the Charleston market specifically, so a name that tied it to the area was very important. This "local first" approach also lent some freedom to the team, as the fight to rectify the state's beer laws did not affect their planning. Their eyes were on the prize, so while the eventual improvement in legislation would certainly help, opening their brewery was not predicated on it.

Holy City Brewing's Chris Brown conducts a small tour of their shiny new brew house, kettle doors flung wide open. *Photo by Chrys Rynearson.*

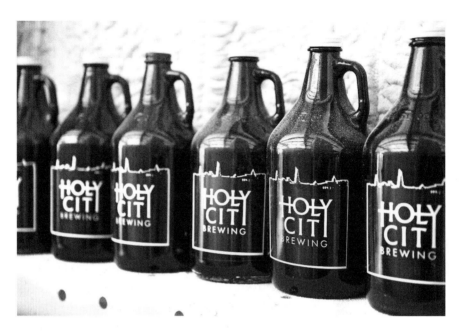

Holy City Brewing growlers line the far wall of the brewery, waiting to be used once the brewery opens. The scattering of sawdust on top of each one denotes a brewery still under construction at the time. *Photo by Chrys Rynearson.*

The brewing equipment would come largely from Canada, including a brand spanking new fifteen-barrel system, seventy-five barrels' worth of fermenter capacity (in three tanks) and forty-five barrels' worth of brite tank capacity (in two tanks). The total startup cost weighed in at a hefty quarter-million dollars, but the space leaves lots of room for growth for the young brewery. A covered outdoor patio will become the tasting zone, thanks in no small part to its view of Holy City's very own two-hundred-year-old live oak tree.

Initial releases will be draft-only for at least the first year, but there is some discussion about packaging some beer at a later date. With the local popularity of growlers, consumers will have no problem getting some beer to go with or without packaging. Holy City launched in July 2011, leading off with two year-rounds, Holy City Pilsner and Pluff Mud Porter. Once things get rolling, the plan is to brew a new seasonal roughly every sixty days as part of its "Fish Bowl" series, the first two of which were an all-Summit hopped IPA and a hoppy imperial red ale. The brewers are no strangers to experimentation, having already brewed pilot batches of bourbon barrel-

aged IPA and bacon porter (brewed with two pounds of cooked bacon), so the seasonals should generate some excitement.

As the Charleston beer scene feels its way through the expansion it is experiencing now, Holy City Brewing will no doubt be a key player. The brewers' commitment to a quality product and abiding love of craft beer will be keys to their success, and local fellow beer lovers will no doubt be by their side to cheer them on.

Frothy Beard Brewing

Charleston has breweries in all stages of the business life cycle, all the way from hatchling to grandpa. They all have one non-beer thing in common— they all started with planning.

Frothy Beard Brewing is currently in that ever-important phase of development. It's the brainchild of three dudes who, through freakish happenstance, all have beards and names that end in vowels: Steve McCauley, Joey Siconolfi and Michael Biondi. The trio resides in Charleston by way of Chicago, the South Carolina Upstate and Brooklyn, respectively. Michael and Joey connected through soccer while attending high school together and later met Steve in a Seneca, South Carolina restaurant where all three were employed at different times.

They parted ways after living together for a summer. Steve left and became a white-water rafting guide, continued (and continues) attending school and also works as an EMS dispatcher. Joey got into the food and beverage world and worked in varying roles in the industry throughout the country. Michael has some background as a restaurateur but also has a master's in entomology and has worked for the Smithsonian in that capacity. Despite an extremely varied experience in the working world, the three stayed in touch and always entertained the idea of opening a business together.

A fateful round of pints in Clemson in the mid-2000s would lead them to try their hand at home brewing, which then spun into a brewery being added to the handful of business ideas they had thrown around over the years. Their devotion to beer was mutually growing, and none of them felt they had fully found their niche. A slow migration to Charleston and probably a few more beers led to them making a serious go of it. Finding kindred spirits in the home brewers of Low Country Libations spurred them on even more and further opened their minds and palates.

The project's name comes from a hodgepodge of influences, from their Tolkien fandom to a desire for something inviting and fun to the woes caused by their own facial hair. The brewery plan is to focus on seasonals and keep the year-round selections to a bare minimum. Their style preferences differ quite a bit, so a varied and changing lineup will be a key to at least keeping the brewers happy. The location isn't yet definite, but the plan for an open-door policy, sustainable brewing practices and deep community involvement is. Expect a maximum of a seven- to ten-barrel brew house from the get-go, possibly a smaller one, and a patchwork of equipment for the balance of the brewing process. Like most breweries, it will start as draft only, but they have aspirations of installing a bottling line once they get their feet wet (and probably sticky).

While there's no definite opening date for Frothy Beard just yet, keep your eyes peeled as they secure a location, equipment and eventually a pint glass near you.

Appendix
The Charleston Beer Guide

Whether you're a visitor to the Holy City or a longtime resident, this appendix will hopefully serve as a brief guidebook to some current craft beer hot spots in the Lowcountry. By no means is it exhaustive, nor is it a glorified list of paid advertisements, so if your favorite establishment isn't here, then please forgive me and thanks for reading. Included are listings and brief descriptions (current at the time of publication) of breweries, pubs and brewpubs and retail spots that I enjoy and are worth a visit. Focus was given to joints that are locally owned and operated, run by folks who care about beer and are working to move our local beer culture forward.

Also included are addresses, websites and Twitter feeds where applicable. In the modern age, Twitter has become a great tool for the beer industry as a quick and easy avenue to spread the word about what's on tap and last-minute events. With so much mobile integration, you can almost direct your barhopping in real time these days. If you've got a Twitter account, follow all these folks to get fully plugged in and up-to-date on the beer scene in Charleston. Or follow me with @CHSBeer, where you'll find all of these accounts in my "Following" list, as well as plenty of re-tweets and occasionally beer-induced color commentary. For advanced tweeters and tweetettes, our local hashtag is #chsbeer.

BREWERIES

COAST Brewing
1250 North 2nd Street, North Charleston, SC 29405
www.coastbrewing.com
@COASTBrewing

COAST is Charleston's second modern brewery, founded in 2007 by the husband-and-wife team of David Merritt and Jaime Tenny. The brew house, located in a repurposed naval records station, is decidedly "green," from the biodiesel generator used to power it, to the largely organic ingredients, to local hog and cow farms that use its spent grain for feed. The two year-round offerings, found both on tap and in twenty-two-ounce bombers, are HopArt IPA and 32/50 Kölsch. Blackbeerd Imperial Stout is an annual release, and COAST has a plethora of ever-rotating seasonals. Tours, tastings and direct sales are offered during specified hours.

Holy City Brewing
4155-C Dorchester Road, North Charleston, SC 29405
www.holycitybrewing.com
@HolyCityBrewing

Holy City is located in a repurposed warehouse tucked away off a busy North Charleston highway. The four-man brewing team fixed up the building and installed equipment largely by hand, planning to create a fun and relaxing space with an old-school feel. Year-round offerings include a pilsner and a porter, with seasonals ranging from pale ale to later barrel-aged offerings. Buzz was circulating even before its opening due to a successful experiment brewing a beer with bacon. Yes, you read that correctly.

Palmetto Brewing Company
289 Huger Street, Charleston, SC 29403
www.palmettobrewingco.com
@palmettobrewing

Founded in 1994, Palmetto is the oldest currently operating brewery in Charleston and the first to open in the state following the end of Prohibition.

It brews four year-round offerings available both on tap and in twelve-ounce bottles throughout the Lowcountry: Amber, Lager, Espresso Porter and Pale Ale. Its seasonal line, Bocat, has included brews such as Watermelon Wheat, Chocolate Bock, Hop Harvest IPA and Extra Pale IPA.

Westbrook Brewing
510 Ridge Road, Mount Pleasant, SC 29464
westbrookbrewing.com
@WestbrookBeer

Founder Edward Westbrook launched this Belgo-centric operation throughout South Carolina in late 2010 with the currently draft-only selections of Belgian Pale Ale and White Thai, along with a limited Amarillo-hopped ale called Batch 1. Subsequent releases have included an IPA, Belgian tripel, Belgian quadrupel and Citra Rye Pale Ale. The roughly $2 million purpose-built brewery spans roughly eighteen thousand square feet and is primed and ready for growth. Expect many seasonal and limited brews here, as the brewery has a dedicated barrel room in which to age special concoctions. Its twenty-tap tasting room is open during specified hours.

BREWPUBS

Folly Beach Brewpub
34 Center Street, Folly Beach, SC 29439
@FollyBrewPub

Life (and traffic) moves a little more slowly at the Edge of America, also known as Folly Beach. Regardless of the speed, natives, surfers and tourists alike often like to end their day in the sun with a beer. There are plenty of spots on and near the main drag, Center Street, to do just that, but those looking for a delicious pint of the good stuff need look no farther than Folly Beach Brewpub. Whether you visit when something from the small in-house brewery is available or not, its six taps pour great (mainly American) craft beer, and a nearby fridge is stocked with equally great bottles. The back-to-basics approach fits the beach scene well—just a bar, some stools, some taps and conversation. There's not room for much else, but who needs much else?

Southend Brewery and Smokehouse
161 East Bay Street, Charleston, SC 29401
www.southendbrewery.com
@SouthendBrewery

The first brewpub in Charleston, Southend remains a staple for locals and tourists with its incredible, historic three-story building on East Bay. Brewmaster Ahren Warf churns out a handful of year-round beers and a rotating seasonal on a bank of taps hooked directly into serving tanks, while the bartenders can serve you from another handful of guest taps as well. With the brew house planted squarely in the middle of the first-floor dining room, it keeps beer on the brains of its customers at all times. Just don't knock on the glass—it's not a zoo, people.

Pubs

Closed for Business
453 King Street, Charleston, SC 29403
www.closed4business.com
@Closed4Biz

While the real wood paneling, wall-mounted deer and flannel-clad staff might make this place feel like a warm-weather ski lodge, Closed for Business has turned into quite the craft beer bar. At last count, it sported forty-two taps, all of which are available in multiple pour sizes, as well as a small bottle selection. It holds regular "kick the keg" specials, hosts local food and beer pairings and taps the occasional cask ale. C4B is clearly jockeying for position as a go-to beer bar in the Lowcountry and is doing quite a job.

Coleman Public House
427 West Coleman Boulevard, Mount Pleasant, SC 29464
www.colemanpublichouse.com
@colemanpubhouse

Coleman Public House straddles the precarious line between being a great restaurant and a comfortable spot to grab a pint with friends. Chef

and owner Brian Tanner is a real Belgian beer fan and keeps a great bottle selection in stock at all times, including as many Trappist ales as possible. That said, its rotating bank of sixteen taps is nothing to sneeze at. It generally features three or four European selections, while the rest is dedicated to great American craft beer. Pair any of those with a gourmet burger, flatbread or full-bore dinner entrée, and you'll be hard pressed to walk away unsatisfied.

EVO Pizza
1075 East Montague Avenue, North Charleston, SC 29405
evopizza.com
@EVOPizza

The Park Circle neighborhood of North Charleston has been undergoing a renaissance for some years, all centered on a strip of Montague Avenue that has been turned into a "downtown" of sorts by local restaurateurs and barkeeps. EVO, short for Extra Virgin Oven and born of a traveling wood-fired pizza operation, was one of its early entrants. Since this isn't the Charleston Pizza Book, just know that the food is delicious and chock full of locally sourced ingredients. The reason EVO appears here is that it remains one of your best beer bets in the area. Six taps, used to fill pint glasses and growlers to go, often feature the latest from local breweries. Its bar was actually the first place to serve beers from COAST Brewing. This is complemented by a rotating list of roughly twenty-five bottles on any given night. Since it is only a stone's throw from COAST, this is a no-brainer for the beer lover who "just happens" to be in the area.

Foster's Pub
545 Belle Station Boulevard, Mount Pleasant, SC 29464
www.fosterspub.net

Located just off Long Point Road, Foster's Pub gets high marks from a diverse crowd of customers. It has an upscale sports bar aesthetic, a bar menu featuring its very own giant burger challenge, a row of sixteen American craft taps and a well-thought-out bottle list that includes a few surprises with higher price points. Owner/operator Craig Foster is a beer enthusiast, and it shows. The pub has held events with Stone Brewing, Avery

Brewing Company and Skull Coast, among others, since opening its doors in February 2010. It's a beer geek's best bet in the northern end of Mount P and couldn't be much closer to Westbrook Brewing.

Gene's Haufbrau
817 Savannah Highway, Charleston, SC 29407
www.geneshaufbrau.com

Gene's is the grandpappy of Charleston beer bars, in every sense of the word. Established in 1952, it is the oldest continuously open bar in Charleston. It had the largest beer selection before Pop the Cap and continues that record today with nearly two hundred selections, though many of those brands are holdovers from our pre-popped days. There's very little pretense to Gene's, just a big room with lots of beer and shelves full of board games. With events like its annual Oktoberfest celebration, it is one of your best bets in West Ashley for a brew.

The Griffon Pub
18 Vendue Range, Charleston, SC 29401
www.griffoncharleston.com
@TheGriffonPub

The folks at the Griffon have won lots of hearts at their casual, English-style pub located very near the waterfront in downtown Charleston. The interior is covered in dollar bills, signed by patrons and stapled wherever they can find a spot (a tough putt these days). Its sixteen quality taps rotate often, there's live music there regularly and it's been known to hold cask events and pint nights on occasion. Beyond that, The Griffon's proximity to Charleston Beer Exchange makes this one an easy visit for the beer enthusiast making his or her rounds in this part of town.

Mellow Mushroom
309 King Street, Charleston, SC 29401
3110 Highway 17 North, Mount Pleasant, SC 29466
19 Magnolia Road, Charleston, SC 29407
www.mellowmushroom.com
@MellowMushChs
@MellowMtP
@MellowAvondale

Back before the cap was popped, there were only a few places in Charleston you could rely on for craft beer on tap, even the limited amount available at the time. Charleston's first Mellow Mushroom on King Street was one of those places. The restaurant chain has since expanded exponentially throughout the country, with three in the Charleston area alone, but banks of craft taps can be found at each and every one. Its bottle selection is also extensive, and each location runs a beer club whose only membership requirement is that you try every single brew in the joint—but not all at once. Mellow Mount Pleasant has further bolstered the local beer scene by running a now-annual beer festival in the fall. Next time you have a craving for interesting pizza and a big beer list, keep an eye out for Mellow Mushroom.

Oak Barrel Tavern
825B Savannah Highway, Charleston, SC 29407
@OakBarrelTavern

The Avondale business district in West Ashley has seen a surge in nightlife over the last couple of years, and Oak Barrel Tavern is one of its latest additions. Oak Barrel occupies a cozy space and offers up a no-frills menu described thoroughly by its signage—craft ales and fine wines. No liquor and no food, just the good stuff, much like its sister location and predecessor, Folly Beach Brewpub. Its six taps regularly pour a variety of styles, with plans to add six more in the future. The bottle list is no slouch either. Its solid selection, the small room and the fun barrel-based décor make this a great place to grab a pint with friends and have a conversation. Look here if you want to escape crowds and noise without straying too far from Avondale's other hot spots.

Sesame Burgers and Beer
4726 Spruill Avenue, North Charleston, SC 29405
2070 Sam Rittenberg Boulevard, Charleston, SC 29407
www.sesameburgersandbeer.com
@SesameBurger

Another early arrival in the Park Circle scene, actually predating EVO, is Sesame Burgers and Beer. The name really says it all—a roughly fifty-bottle selection and a handful of taps complementing burgers ground in-house and garnished with house-made fixins (among other things). Sesame served as my first introduction to COAST, which you can still always find on tap. Its second location in the Citadel Mall offers the same menu and relatively same beer selection with a slightly more modern feel. While I'm an old devotee of the original, the novelty of locally brewed craft beer in a shopping mall has yet to get old for me. Find a better combination than a medium-rare burger and a pint of HopArt IPA and I'll eat your hat. Okay, I won't eat your hat, but I will buy myself a pint and apologize.

Smoky Oak Taproom
1234 Camp Road, Charleston, SC 29412
smokyoak.com
@SmokyOakTaproom

Smoky Oak has become a dominant force in craft beer on James Island (between the peninsula and Folly Beach). It boasts forty-one craft taps, often with some very special selections in the mix. Add to that an impressive barbeque-centric menu, and it's hard to go wrong. On the event side, it has hosted three outdoor "Beer-B-Que Bash" festivals so far, one every six months since the first one, each featuring an impressive and varied lineup of roughly fifty beers for a low per-sample price. Though it started as a neighborhood favorite, tucked safely away off the main drag, word is getting out that Smoky Oak is a local beer destination.

Retail

Charleston Beer Exchange
14 Exchange Street, Charleston, SC 29401
www.charlestonbeerexchange.com
@BeerExchange

There's a reason these guys got their own chapter. Since opening in late 2008, their small store in the southern end of downtown Charleston has become the epicenter of the local beer world. The nine-tap growler station is the site of weekly "Rare Beer Tuesday" events, and their selection of nine hundred-odd bottles can make even the most seasoned beer geek weak in the knees. Their involvement in local beer events, beer dinners, Charleston Brewvival and other ventures all emanates from this home base, so if you're here and you love beer, you need to make a point to visit. Besides all that, they are genuinely nice guys with varying degrees of facial hair.

House of Brews
1537-C Ben Sawyer Boulevard, Mount Pleasant, SC 29464
www.houseofbrewsmtp.com
@houseofbrewsmtp

As you approach the Sullivan's Island Bridge on Ben Sawyer Boulevard, there's a new house to visit. House of Brews is an unassuming abode slightly removed from the highway. The homey interior plays host to over three hundred bottles and four taps for your beer needs but also serves up tea, coffee, some wine and a handful of gifts. The taps fill growlers but also glasses for folks who want to enjoy a pint inside or on the lawn out back. Owner Rob Davis recognized an unfilled niche in the immediate area and is doing his best to fill it with good company and delicious beer.

Laura Albert's
891 Island Park Drive, Daniel Island, SC 29492
www.lauraalberts.com
@LauraAlberts

Daniel Island has spent the past few years turning into a fairly swanky area. It's the home of the Family Circle Tennis Cup, Blackbaud Stadium and a number of notable restaurants. Laura Albert's has added multiple things to the mix. Owner/operator Karen Elsey has turned the store into a jack-of-all-trades, if you will. It's a retail spot for beer with a growler station, a retail spot for wine and a gift shop. Also, it's a restaurant where you can order a pint straight from the growler station or a glass of wine and drink on the premises. It hosts beer dinners and pint nights on occasion, as well as wine events. I don't know of any single joint that does such a variety of things, but it remains your best beer bet on the Island, with enough non-beer distractions to occupy any non-beer folk you may have in tow.

TAPS Brews
9770 Dorchester Rd #104, Summerville, SC 29485
www.tapsbrews.com
@TAPSBrews

Thirsty citizens of Summerville have recently had cause to celebrate, as TAPS Brews has brought dedicated craft beer retail within their city limits. Its selection includes nine taps and an extensive bottle shelf holding about four hundred varieties at any given time. Like some of these other joints, TAPS also serves on premise, so the taps can fill a growler or a pint glass and every bottle on the shelf can also be found in the cooler. The menu is rounded out by a small splash of wine offerings, but that's the extent of the operation. Locals can join the beer club for a small fee, earning rewards for purchases. More recently, TAPS has started stocking some home-brewing supplies, making it the only retail source for them in the area.

Ted's Butcherblock
334 East Bay Street, Charleston, SC 29401
www.tedsbutcherblock.com
@Butcherblock

Ted's is another pioneer in craft beer around these parts, stocking a small but important collection even before the cap was popped. Its beer selection was originally curated by Scott Shor, now co-owner of Charleston Beer Exchange. Scott still collaborates with Ted Dombrowski and co-hosts the area's longest-running regular beer dinner series with him. Like some other spots in town, you can purchase a chilled (bottled) beer to go or crack it open with your meal. In addition to beer, it offers great sandwiches for lunch, regular and reasonably priced dinner menus and a completely insane meat and deli selection, as the name might imply.

Total Wine
1820 Ashley River Road, Charleston, SC 29407
www.totalwine.com

While it may be a "corporate entity," Total Wine deserves a shout-out here for having and keeping a huge retail beer selection even before we popped the cap. While I avoided the place when it first took over the space that had housed an old Harris Teeter, thinking it was a wine-only affair, I finally ventured in to witness the biggest area beer selection I had seen to date in the back of the store. Keeping up with the times, its beer section has grown and now also accommodates a six-tap growler station. One benefit of its size is that it often has kegs on hand, for those beer lovers with enough friends to warrant that kind of quantity.

Wine Awhile
1039 Highway 41, Suite 200, Mount Pleasant, SC 29466
www.wineawhile.com
@wineawhile

As one might expect, Wine Awhile is a wine-centric affair. The hybrid retail shop/bar offers an extensive bottle selection to take home or enjoy in the store, along with a short menu of snacks to pair. But wine didn't

get it a mention here. The six-tap growler station and small, respectable bottle selection (some chilled, some not) did. The growler station is also the source of pours for pints and half-pints. There's a soft spot in my heart for half-pours, but even so, you won't find a better retail spot for beer on the northern outskirts of Mount P.

Bibliography

BOOKS

Brown, John Hull. *Early American Beverages*. New York: Bonanza Books, 1966.

Cohen, Hennig. *The South Carolina Gazette: 1732–1775*. Columbia: University of South Carolina Press, 1953.

Confederate Receipt Book: A Compilation of Over One Hundred Receipts, Adapted to the Times. Athens: University of Georgia Press, 1960.

Daniels, Ray. *Designing Great Beers*. Boulder, CO: Brewers Publications, 1996.

Eubanks, John Evans. *Ben Tillman's Baby: The Dispensary System of South Carolina*. Augusta, GA: Tidwell Printing, 1950.

Hash, C. Patton. *Charleston: Alone Among Cities*. Charleston, SC: Arcadia Publishing, 2000.

Haskell, Helen Woolford. *The Middleton Place Privy House: An Archaeological View of Nineteenth Century Plantation Life*. Columbia: University of South Carolina Institute of Archaeology & Anthropology, *Popular Series 1*, 1981.

Huggins, Phillip K. *The South Carolina Dispensary*. Columbia, SC: Sandlapper Press, 1971.

Jones, Mark R. *Wicked Charleston: The Dark Side of the Holy City*. Charleston, SC: The History Press, 2005.

———. *Wicked Charleston Volume 2: Prostitutes, Politics and Prohibition*. Charleston, SC: The History Press, 2006.

Kantrowitz, Stephen. *Ben Tillman and the Reconstruction of White Supremacy*. Chapel Hill: University of North Carolina Press, 2000.

LaFrance, Peter. *Beer Basics: A Quick and Easy Guide*. New York: John Wiley & Sons, 1995.

Lieurance, Suzanne. *The Prohibition Era in American History*. Berkeley Heights, NJ: Enslow Publishers, 2008.

Orkent, Daniel. *Last Call: The Rise and Fall of Prohibition*. New York: Scribner, 2010.

Rosen, Robert. *A Short History of Charleston*. Columbia: University of South Carolina Press, 1992.

Salinger, Sharon V. *Taverns and Drinking in Early America*. Baltimore, MD: Johns Hopkins University Press, 2002.

Teal, Harvey S., and Rita Foster Wallace. *The South Carolina Dispensary & Embossed S.C. Whiskey Bottles & Jugs, 1865–1915*. Camden, SC: Midlands Printing Company, 2005.

Tillman, Stephen Frederick. *Spes Alit Agricolam (Hope Sustains the Farmer)*. Washington, D.C.: Goetz Company, 1962.

Woody, Howard, and Thomas L. Johnson. *South Carolina Postcards Volume I: Charleston, Berkeley, and Dorchester Counties*. Dover, NH: Arcadia Publishing, 1997.

Zierden, Martha A. *Archaeological Excavations at McCrady's Longroom*. Charleston, SC: Charleston Museum, 1982.

ARTICLES IN PRINT

Leland, John G. "Early Taverns in Charleston." *Preservation Progress*, Preservation Society of Charleston, May 1971.

———. "Many Bottles Emptied, Few Made, Locally." *News and Courier*, March 31, 1970.

Mosier, Andrew. "The Brew Crew." *Charleston Magazine*, December 2007.

News and Courier. "The Ale Boycott." March 4, 1890.

———. "The Ale Boycott." March 11, 1890.

———. "The Ale Boycotters." March 16, 1890.

———, April 1, 1890.

———, April 16, 1890.

———. "Boycotting the Boycotters." March 8, 1890.

———. "Chicco Funeral This Afternoon." October 26, 1928.

———, March 9, 1890.

———, March 12, 1890.

———. "The Palmetto Brewery." March 12, 1890.

———, September 7, 1886.

Plyler, Jo Anne. "The Earthquake of 1886." *News and Courier*, August 30, 1964.

Quick, Dennis. "Local Brewery Satisfies South Carolina Beer Drinkers." *Charleston Regional Business Journal*, June 8, 1998.

Stockton, Robert P. "Taverns, Strong Drink Are Local Institutions." *News and Courier*, July 29, 1974.

Walsh, Walter Richard. "Edmund Egan: Charleston's Rebel Brewer." *South Carolina Historical Magazine*, October 1955.

NEWSPAPERS ACCESSED VIA ACCESSIBLE ARCHIVES (WWW.ACCESSIBLE.COM)

South Carolina Gazette, February 26–March 4, 1732.

————, August 19–August 26, 1732.

————, November 25–December 2, 1732.

————, February 9–February 16, 1734.

————, February 22–March 1, 1735.

————, January 17–January 24, 1736.

————, January 31–February 17, 1736.

————, April 26–May 3, 1739.

————, April 18, 1748.

————, May 27, 1751.

————, February 22, 1752.

————, January 30, 1770.

————, October 4, 1770.

————, November 26, 1772.

————, November 22, 1773.

————, February 21, 1774.

Articles Accessed Online

Alström, Jason, and Todd Alström. "The Growler: Beer to Go!" *Beeradvocate*, July 31, 2002. beeradvocate.com/articles/384.

Ferrell, Adam. "Breweries Tap into City's History." *Post and Courier*, July 10, 2003. archives.postandcourier.com/archive/arch03/0703/arc07101243237.shtml.

Lawrence, Stratton. "Craft Beer Enthusiasts Try Again to Decriminalize Tastings in S.C." *Charleston City Paper*, May 5, 2010. www.charlestoncitypaper.com/charleston/craft-beer-enthusiasts-try-again-to-decriminalize-tastings-in-sc/Content?oid=1946306.

Lesemann, T. Ballard. "Brewvival Pitches a Tent for Beer Lovers." *Charleston City Paper*, January 4, 2010. www.charlestoncitypaper.com/charleston/brewvival-pitches-a-tent-for-beer-lovers/Content?oid=1670245.

———. "Westbrook Brewing Co. Hopes to Be on Taps Around Town Come September." *Charleston City Paper*, July 7, 2010. www.charlestoncitypaper.com/charleston/westbrook-brewing-co-hopes-to-be-on-taps-around-town-come-september/Content?oid=2119379.

New York Times. "First Arrest in Charleston." July 16, 1893. query.nytimes.com/mem/archive-free/pdf?res=F20A1EFB3F5A1A738DDDAF0994DF405B8385F0D3.

Papazian, Charlie. "Asheville, NC Continues Its Reign as Top BeerCity USA 2010." *Examiner.com*, May 24, 2010. www.examiner.com/beer-in-national/asheville-nc-continues-its-reign-as-top-beercity-usa-2010.

Petersen, Bo. "Crafting Change." *Post and Courier*, January 14, 2011. www.postandcourier.com/news/2011/jan/14/crafting-change.

Pettigrew, Timmons. "South Carolina Craft Brewery Tasting Bill Makes It to the Senate." *TheDigitel Charleston*, April 28, 2010. charleston.thedigitel.com/food/south-carolina-craft-brewery-tasting-bill-makes-it-20875-0526.

———. "Westbrook Brewing Gets Tanked, and We've Got the Time Lapse Video to Prove It." *TheDigitel Charleston*, September 2, 2010. charleston.thedigitel.com/arts-culture/westbrook-brewing-gets-tanked-and-weve-got-time-la-23168-0902.

Simonson, Robert. "Growlers, the New Old Way to Tote Your Beer." *New York Times*, January 26, 2010. www.nytimes.com/2010/01/27/dining/27growl.html?_r=2.

Smith, Glenn. "Brewvival to Showcase Craft Beers." *Post and Courier*, February 1, 2010. www.postandcourier.com/news/2010/feb/01/brewvival-to-showcase-craft-beers.

———. "Tour and Taste: Breweries Now Can Show Off Their Skills—in Moderation." *Post and Courier*, June 20, 2010. archives.postandcourier.com/archive/arch10/0610/arc062010121893.shtml.

St. Onge, Peter. "S.C. Growler Sales Have N.C. Beer Sellers Grousing." *Charlotte Observer*, January 10, 2010. www.charlotteobserver.com/2010/01/10/1171128/sc-growler-sales-have-nc-beer.html.

Test, Samantha. "Do You Like Beer?" *Post and Courier*, June 18, 2009. www.postandcourier.com/news/2009/jun/18/cover86344

Wise, Warren. "Brewing Up Beer, Success," *The Post and Courier*, November 27, 2010, http://www.postandcourier.com/news/2010/nov/27/brewing-up-beer-success/.

———. "Entrepreneur: Big Goals for Microbrewery." *Post and Courier*, May 14, 2010. www.postandcourier.com/news/2010/may/14/entrepreneur-has-big-goals-for-microbrewery.

———. "4 Guys Dream Up Holy City Brewing." *Post and Courier*, February 3, 2011. www.postandcourier.com/news/2011/feb/03/4-guys-dream-up-holy-city-brewing.

INTERVIEWS

Addis, Les, founder, Gravity Distributing. E-mail message to the author, May 2011.

Biondi, Michael, co-founder and co-owner, Frothy Beard Brewing. E-mail message to the author, April 2011.

Brewer, Brent, president, Low Country Libations. In discussion with the author, March 2011.

Carl, Joel, and Chris Brown, co-founders and co-owners, Holy City Brewing. In discussion with the author, March 2011.

Falkenstein, Ed, co-founder and co-owner, Palmetto Brewing Company. In discussion with the author, April 2011.

Shor, Scott, co-founder and co-owner, Charleston Beer Exchange. In discussion with the author, January 2011.

Tenny, Jaime, co-founder and co-owner, COAST Brewing. In discussion with the author, March 2011.

Warf, Ahren, brewmaster, Southend Brewery and Smokehouse. In discussion with the author, April 2011.

Westbrook, Edward, founder, Westbrook Brewing. In discussion with the author, March 2011.

WEBSITES

"Best Beer Retailers 2011." Ratebeer. www.ratebeer.com/RateBeerBest/table_2011.asp?title=Best+Beer+Retailers+2011&file=retailers_places_2011.csv.

"Facts." Brewers Association. www.brewersassociation.org/pages/business-tools/craft-brewing-statistics/facts.

"History." Grand Teton Brewing Company. www.grandtetonbrewing.com/History.html.

"North Carolina Breweries." North Carolina ABC Commission. www.ncabc.com/product/brewery_winery.aspx.

"Purchasing Power of British Pounds from 1264 to Present." Measuring Worth. www.measuringworth.com/ppoweruk.

DVD

Sherman, Roger, and Jesse Sweet. *The American Brew*. Directed by Roger Sherman. Washington, D.C.: Here's to Beer, Inc., 2007.

Legislation

Title 61, Chapter 4, Article 1, South Carolina Code of Laws.

South Carolina House Bill 3218, Session 117, 2007.

South Carolina House Bill 3693, Session 118, 2009.

South Carolina House Bill 4572, Session 118, 2009.

Legal Documents

Mitchell & Smith. *Ale Boycott Records*, 1890. (152.07.01) South Carolina Historical Society.

————. *Germania Brewing Co. bankruptcy records*, 1915–1918. (152.07.04) South Carolina Historical Society.

Index

About the Author

Timmons Pettigrew resides in West Ashley with his wife and pets (in that order). His full-time gig is in industrial distribution pricing strategy, but he's also the beer writer for TheDigitel Charleston, a local media aggregator. If you're reading this, that means he also wrote a book.

His status as a beer geek is ironic, considering he's a direct lineal descendant of "Pitchfork" Ben Tillman. The Lowcountry got a hold of him while he lived here attending College of Charleston. Graduate work in economics at the University of South Carolina pulled him away for a spell, but he came back directly, and there's no place he'd rather live. While visiting Asheville, North Carolina, in November 2006, Timmons drank his first bottle of Weyerbacher Double Simcoe Ale, and he has never looked back. You can read his ongoing local beer coverage at charleston.thedigitel.com, CHSBeer. org and on Twitter via @CHSBeer.

ABOUT THE PHOTOGRAPHER

Chrys Rynearson arrived in Charleston by way of Germany, where he was stationed for six years with the U.S. Navy. Never mind that it's a landlocked country, there's more important reasons for the navy to be there—like the beer! Chrys sampled his fair share of great beer during his travels and returned to the Charleston area with a higher alcohol tolerance, eager to see what the Southeast had to offer. A beer geek's geek, he's always helping out with website builds, videos or photo shoots for most of the local breweries and craft beer organizations. This includes, but is not limited to, Brewvival. com, SouthCarolinaBeer.org, CharlestonBeerWeek.com, CHSBeer.org and, oh yeah, this book. He can be found online (naturally) at exposur3.com or on Twitter via @exposur3.

TASTING NOTES

Visit us at
www.historypress.net